REALLY, REALLY, REALLY
EASY STEP-BY-STEP
DIGITAL
PHOTOGRAPHY
for absolute beginners of all ages

Gavin Hoole and Cheryl Smith

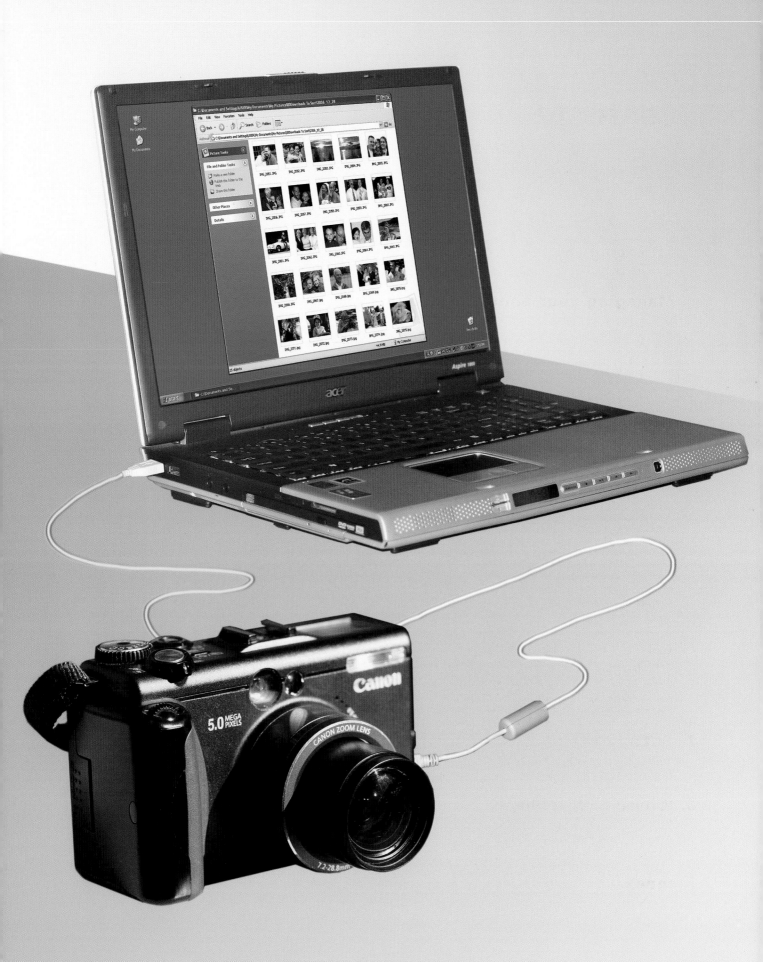

Contents

Read this before you start

OVERVIEW
This chapter gives a brief introduction to digital photography, and explains how to use this book.

THE CHANGING FACE OF PHOTOGRAPHY
Most of us are pretty familiar with how traditional photography works. You insert a film into your camera (away from bright light) and take some photos. When the roll is 'full' you take it to a photo shop to have the film developed into 'negatives' and presented to you as photographs printed on photographic paper. From there on there's not much you can do besides file your photos in an album to show them to friends and family. If you want extra copies to send away by mail you have to go back to the photo shop and pay for more 'prints'.

While you're busy shooting your photos you have no idea whether the pictures will look good once they're printed. So you either waste money taking extra shots 'in case', or you take a chance and hope that you have a spool full of good photos, often to find out later that several of them are unsatisfactory – blurred, out of focus, too bright, too dark, or someone happened to walk in front of the lens just as you were pressing the button to capture a memory of a lifetime with the last available shot on the film. And there's nothing you can do about it.

Well, the good news is that digital photography changes all of this. It opens up a whole new range of benefits while empowering the amateur photographer as never before – not only at the time of taking photos but even more so once the photographs are off the camera. By being able to experiment with no major expenses involved, amateurs are discovering a creative talent they didn't know they had.

By using a personal computer, perhaps a scanner and photo editing software too, it's now easy to have fun creating unusual effects, or simply repairing sub-standard pictures. The pictures on the opposite page show how one can use a little imagination and creativity to embark on an interesting new hobby – digital photography.

WHAT IS DIGITAL PHOTOGRAPHY?
In a nutshell, digital photography eliminates the use of light-sensitive film and the need for chemicals (an environmental issue these days) used in developing and printing the exposed film as photographs. Instead, it uses digital technology in much the same way as a computer does.

The digital camera still has a lens through which light passes, and the usual kinds of settings that the photographer can adjust for light, focus, and so on. But instead of a bulky spool of light-sensitive film inside the camera, it has a small electronic light sensor called a charge-coupled device, or sensor for short, which captures and stores the images. When light coming through the lens falls on the sensor it is converted into a digital format. And this is where the digital era's magic starts for the user.

With your photos now in digital format, either still inside your camera's own memory or on small removable storage devices, they can be transferred to a computer from where the wide range of possibilities is very exciting. So, besides no longer needing to buy new rolls of film or engage in the whole film processing 'mission', your captured photos can now stay with you, to be managed and edited by you on a computer as you see fit.

 To enjoy the maximum benefit from digital photography, and from this step-by-step book, you'll need to have access to a computer and a digital camera. For the computer-related aspects of digital photography this book is based on the Windows XP operating system. If you're using a different operating system, then you'll need to adapt where appropriate.
If you have no computer experience at all, we recommend our companion books, *The Really Really Really Easy Computer Book 1* and *Book 2*.

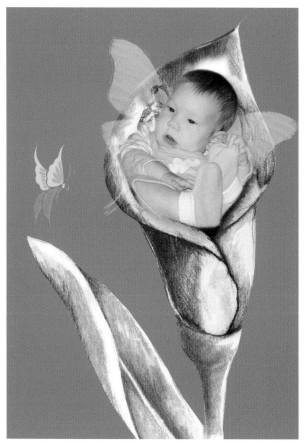

Composite picture using scanned charcoal *drawings*
(the lily, some wings and a butterfly)
and a baby photograph.

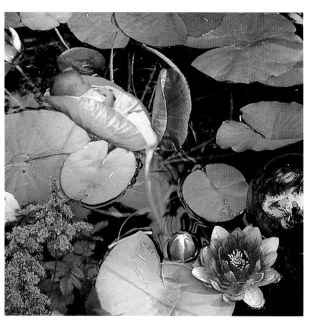

Composite picture made up of *four different* photos:
1. picture a baby
2. photo of flowers
3. various shots of lily pads, and
4. shot of still water

Here's a picture of an ordinary white flower. Using photo software on a home computer to add subtle lighting and coloured filters to match your home decor, a high-resolution composite can be constructed suitable for printing, framing and hanging on a wall.

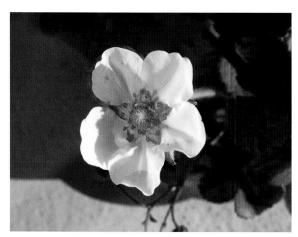

Original photograph

The same photo, after cropping and adding
various colour filters.

BENEFITS OF DIGITAL TECHNOLOGY

Cost-effectiveness

- **No developing costs:** There's no longer a need to pay to have your films developed. There is in fact no film. Your photos are already stored in digital format and once they've been 'downloaded' onto a computer they can be viewed on your computer monitor (screen) at no extra cost.

- **No wasted film through poor pictures:** The camera has a display that enables you to see instantly (as soon as you've taken the picture) what the photo looks like. So you can improve your photographic skills and experiment to your heart's content with different settings without wasting what would have been expensive film. If the photo isn't good enough you can delete it from the camera immediately (or later) and retake the picture there and then.

- **Make multiple copies at no cost:** Once you have your photos stored on a computer, CD-ROM or DVD disk, you can make as many digital copies as you like or share the same copy digitally with as many people as you wish without having to run to the photo shop and pay for extra prints. So instead of incurring printing and postage costs you can, for example, e-mail your photos to all your friends and family, or put them on a Web page so that family and friends can view them on their own computers and make their own prints using their own ink-jet or laser printers.

Self-empowerment

- **Edit your photos yourself:** Make them smaller, crop off parts you don't want, lighten or darken them, add text, add highlighting symbols like arrows or circles, use filters to make them look like watercolours or oil paintings, 'stitch' together a series of multiple images to create a wide panorama, and so on.

- **Use your photos on a Web page:** Display your favourite photos on the World Wide Web for all to see. Many free Web sites host photos for amateurs, and it is easy to upload your own photos to these sites.

- **Distribute your photo album on a CD-ROM disk:** Your photo album (e.g. a set of photos of a recent wedding) can be put onto CD-ROM disks and mailed to family and friends as their personal photo album.

- **Make your own greeting cards:** Insert your photos into greeting cards that you can print and send, either via post or by e-mail.

- **Prepare interesting business reports and slide shows:** Use your photos to demonstrate visually the information or impression you are wanting to convey –

You can create special cards

products, situations, and so on – in either a business report or a full-colour slide show. These can even be put on CD-ROM disks and distributed to your audience for viewing in their own time on their own computers.

- **Liven up newsletters with digital photos:** Newsletters from your club, association, committee, and so on can be made more interesting by including full-colour photos.

- **Create photo-illustrated school and college homework projects:** Make your projects more interesting and improve your grades.

- **Display your photos on a TV set or a multimedia projector:** Enable a whole room of people to view your photos at the same time as a slide show.

- **Print your photos yourself:** Print your own photos on photo paper available from most computer and stationery stores, either as full-size photos or set out economically with several pictures on a sheet.

- **Use your photos for speciality printing:** Send your photos electronically to firms offering a service for printing onto T-shirts, coffee mugs, key rings, mouse pads etc.

- **Convert your photos to slides:** Show them on a slide projector.

- **Manage your collection easily:** Use your computer to create a well-organized digital photo collection; no more bulky, labelled boxes or packets. You can now file them all neatly in folders on your computer or on CDs so that you can find them in a jiffy.

These are some of the ways in which the digital era has changed the nature of photography and made so much more available to so many amateurs and budding photographers. In the next chapter you'll start learning how to do many of these fun activities. But first we'd like to cover a few preliminaries about getting the most out of this book.

A personalized key ring is the perfect gift for a special person in your life

Your images can be used to decorate various items, such as this mug

How to use this book

This book consists of two parts:

Part 1: *Working with digital photos (pp 10–63)* **–** shows you how to manage your photo collection in an organized way and how to edit photos (crop, resize, fix colour, etc.), send them by e-mail, and so on.

Part 2: *Taking digital photos (pp 64–109)* **–** is about the digital camera itself and how to take good digital photographs and get them onto a computer.

We've deliberately structured the book in this particular sequence to make it easier for a beginner to start immediately with the fun part of working with photographs, even without necessarily owning your own digital camera. By following the step-by-step procedures using photos and software we've provided for this purpose, you'll quickly come to realize how easy it is to achieve the kinds of results often thought to be the exclusive domain of the experts. Now you can become an expert too.

Once you've worked through Part 1, it will then be easier to work through Part 2 and apply your knowledge to your own particular brand of digital camera and editing software.

If you're in a hurry to learn how to use a digital camera and take photographs, and that's your immediate priority, then feel free to jump straight to Part 2 and come back to Part 1 later. However, if you're a real beginner we suggest that you work through the book in the sequence in which the material is presented.

Computer screen shots and photographs are used throughout the book to clarify what you'll see on your computer screen and to show you the effects of the various photographic and editing procedures and techniques.

For Part 1: Working with digital photos – you'll need to download from our Web site (see pp12–13) the photos you'll be using in the practical exercises, as well as a free photo editing program that you'll be using to learn the basics of photo management and editing. Step-by-step instructions of how to do this are given on the Web site.

THE USER-FRIENDLY VISUAL SYSTEM

This book's user-friendly system makes it really, really, really easy for anyone to enjoy learning how to get started with digital photography. Colour-coded windows are used throughout the book so that you can see at a glance the type of information you're looking at:

- Introductions and explanations in normal black text on a white background;

- Step-by-step procedures in yellow boxes;

- Hints and tips in blue boxes;

- Very important notes and warnings in boxes with red borders;

- Exercises in green boxes;

Have fun!

Preparing for the tutorials 1

OVERVIEW

This chapter shows you how to obtain and set up a free photo-editing software program as well as how to download the digital photos that you'll need for the tutorials that follow.

CREATING FOLDERS FOR THE TUTORIAL PHOTOS

We've prepared six digital photos for you to use for the practical aspects of photo management and editing as taught in this book, so let's create a filing system for them right now. The following procedures for doing this can also be used to set up a folder filing system later for use with your own photo collection.

We'll start by creating a main folder for this event or theme, and we'll call it *Tutorial*. Then we'll create a sub-folder called *Originals* into which you'll download the photos from our Web site. (You'll later be creating a second sub-folder for your edited copies. By having two sub-folders you'll always have the originals on file in case you need to revert to them later. This will be explained in Chapter 2.)

1. In Windows Explorer (or My Computer), double-click on the folder named **My Pictures** to open it. (Alternatively, click on **Start**, then **My Pictures** to open the My Pictures folder.)

Now let's make sure we're all seeing the same screen layout.

2. In the Explorer window that opens, on the Toolbar click on the Folders icon to open up the left-hand pane and show the drives and folders on your computer.
3. On the Menu Bar click on **View**, then **Details** to be able to view the details of the folders in the right-hand pane. Your screen should now look something like this:

4. With the My Pictures folder selected, click on **File**, then **New**, then **Folder**.

5. A new folder icon will appear with a small renaming box next to it containing the words **New Folder** highlighted in blue.

6. In this small renaming box type the name **Tutorial**, and press . The new folder's name will now appear on the right of the folder.

TIP: RENAMING A FOLDER

If you make a typing mistake, right-click on the new **Tutorial** folder to open the drop-down menu, then click on **Rename**. This allows you to retype the folder name correctly.

Creating an *Originals* sub-folder for the photos

1. In Windows Explorer, **double-click** on your new **Tutorial** folder to open it.
2. On the Menu Bar, click on **File**, then on **New**, then **Folder**.
3. In the small renaming box that opens type the folder name **Originals** and press ⏎.

Within the *Tutorial* folder you should now have one new sub-folder called *Originals*. (You may also have other folders besides *Tutorial* that you have previously created under *My Pictures* to store images you already have on your computer. For the purposes of the tutorials we're showing just the *Tutorial* folder and its *Originals* sub-folder.)

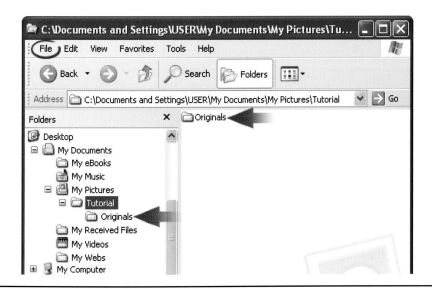

TIP: CREATING A NEW FOLDER IN THE RIGHT PLACE

When creating a new folder or sub-folder, be sure that you first double-click on the folder within which you want to create your new folder; otherwise the new folder might be created in the wrong place in your filing system. If you mess up and create it under the wrong folder, you can of course select the new folder, press `Ctrl` + `x` to cut it, then double-click on the folder under which you want to place it, and press `Ctrl` + `v` to paste it there. If you are familiar with the 'drag and drop' method, then that's another way of moving a folder to its desired location.

INSTALLING FREE PHOTO EDITING SOFTWARE

Most digital cameras come with their own software (computer program) on a CD for downloading, viewing and editing the photographs you've taken. However, the many users of this manual will have different brands of camera software installed, and some may not have any photo software installed at all.

So, to make life easier for all, whether or not you already have camera software installed, we'll be using a nifty software program in the step-by-step photo editing and file management procedures that follow. The program is called Picasa®, a free program from Google®, that can be downloaded from our companion Web site. Once you've installed Picasa®, it's yours to keep – free of charge.

1. Connect to the Internet.
2. Go to our companion Web site at **http://www.reallyeasycomputerbooks.com/** and click the **Digital Photography** link.
3. On the page that opens click on the link for downloading **Picasa®**.

TIP: HOW TO DOWNLOAD

If you're not familiar with the procedure for downloading programs from the Internet, on our Web site click on the link **Instructions for Downloading and Installing Picasa®** to read the full instructions on how to download and install **Picasa®**.

DOWNLOADING THE TUTORIAL PHOTOS

Now you'll need to download the six photos we've specially prepared for you to work with in the photo editing exercises that follow. These photos have been created to simulate a size that might come from a digital camera. They can be downloaded from this book's companion Web site.

1. Connect your computer to the Internet.
2. Go to this Web site: **http://www.reallyeasycomputerbooks.com/**
3. Once you've entered the Web site, click on the **Digital Photography** tab at the top of the Web page.
4. On the **Digital Photography** Web page that opens, click on the link **Download Images For Digital Photography Tutorials** to go to the page of photographs to be downloaded, and follow the instructions.

Once you've finished downloading the six photos to the recommended directory, your file listing in Windows Explorer should look like this:

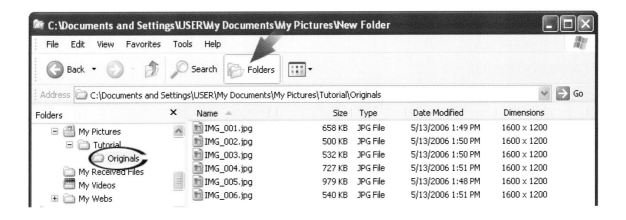

TIP: SEEING THE SIZE OF IMAGE FILES

It's often useful to know the sizes of the image files (see the right-hand pane in the illustration above). To do this, on the **Menu Bar** click on **View**, then **Details**. (To see the hierarchy of folders in the left-hand pane, on the **Toolbar** click on the **Folders** icon.)

Managing your photo collection 2

OVERVIEW
In this chapter you'll learn some basic photo management methods that will help you quickly find the photos you want for viewing, editing, printing, e-mailing and so on. It will also help you to find your way around the Picasa® program you installed in Chapter 1, which will be useful when you use the editing techniques in the next chapter.

SETTING UP A WORKABLE SYSTEM
The modern digital equivalent of the old cardboard photo storage boxes and photo albums is the personal computer. If you've been using a computer for a while, you'll already know how quickly your system can become cluttered with many files you no longer need. Not only can this take up a lot of hard drive space, but it can also make it difficult to find files when you need them.

Computer clutter becomes even more accentuated when the number of digital photos on your computer grows and grows. This happens for several reasons:

- It's not expensive to take lots of photos, so one tends to do just that.
- Image files are larger than many other file formats, so they take up more hard drive space.
- It's so easy to edit your own photos that one tends to end up with multiple versions of the same photo.
- One also accumulates image files received as attachments in e-mails from others.

The end result of all of this is that one usually ends up with hundreds, often thousands of photos and other images on one's computer, often scattered around in various folders in different directories. So a good file finding system is absolutely essential.

> **!** It is critically important to plan how you intend managing your portfolio of the many photos you'll probably collect over time. Set up an effective photo management system right from the start that will enable you to find what you're looking for quickly and without frustration. If you don't do this now, you'll regret the fact that you didn't.

FOLDERS VS SOFTWARE FOR IMAGE MANAGEMENT
In this chapter we'll cover two of the popular methods used for managing one's digital images – the traditional method of creating a hierarchy of folders and sub-folders (see illustration), and the more 'liberated' method of using image management software.

Some people use folders exclusively, while others prefer to use effective software to find what they're looking for. Yet others use both methods together and choose the method that is appropriate to what they're doing at the time.

We'll start with the traditional method of filing everything in folders, as we did in the first chapter when the tutorial photos were downloaded. Then we'll explain the alternative approach of using image management software, such as Picasa®. But first, let's clarify what happens when photos are downloaded from the camera.

```
Folders
☐ 🖵 My Pictures
   ⊞ 🗀 00Downloads To Sort
   ⊞ 🗀 Christmas-2003
   ⊞ 🗀 Christmas-2004
   ⊞ 🗀 Christmas-2005
   ⊞ 🗀 Christmas-2006
   ☐ 🗀 Grandchildren
        🗀 Originals
   ☐ 🗀 Nature-Birds
        🗀 Originals
   ⊞ 🗀 Nature-Flowers
   ⊞ 🗀 Tutorial
   ⊞ 🗀 Vac-Canada 2005
   ⊞ 🗀 Vac-France 2006
   ⊞ 🗀 Vac-Spain 2007
   ⊞ 🗀 Wedding-Becky 2004
   ⊞ 🗀 Wedding-Quinton 2006
```

14

HOW THE CAMERA SOFTWARE NORMALLY HANDLES DOWNLOADS

Once you've taken some photos with your digital camera, instead of taking a roll of film to a photo shop for developing and printing, you'll download the photos from the camera to a computer or printer (usually a personal computer). When you download a batch of photos, normally the camera's software will automatically create and name a new download folder for you for that particular download batch. It will be named either with the download date or some other numeric reference.

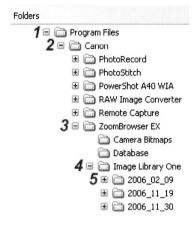

What you need to decide is *where* on your hard drive that download folder should be created. Sometimes the camera's software will automatically create its folder somewhere in C:/Program Files/ and not in *My Pictures*. This can result in a rather lengthy folder hierarchy that makes it quite a 'mission' if you want to get to your photos in a hurry (see the five levels in the file hierarchy illustration). It makes things much easier if you create a folder within *My Pictures* that is used exclusively for photo downloads from the camera.

Another thing worth noting, the camera gives each photo a numerical file name such as IMG-057, IMG-058 and so on. This isn't very useful when you're later trying to find the photos of your cousin's wedding, or some other event or theme. So we'll look at how to rename photos and to do it in time-saving batches rather than individually.

A typical camera-generated folder system showing the many levels in the folder hierarchy

Managing your photos with folders

With the folders method there are essentially two stages in the saving of photos into their final destination folders:

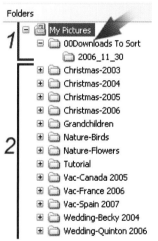

1. **Stage 1:** downloading the photos from the camera into a camera-created folder which it names with the download date or some other camera-given name. (It is best to have these download folders go inside a folder named 00Downloads To Sort. (By typing 00 as a prefix to Downloads To Sort, that folder will always remain at the top of the hierarchy of folders for easy finding.) – see stage 1 in the illustration); and

2. **Stage 2:** sorting through these photos in thumbnail view and transferring them into various pre-named folders organized by topic, event or theme (see stage 2 in the illustration). If you really want to be organized, you can name each of these folders with a prefix related to a particular category of event or theme so that when Windows Explorer displays all your folders, usually in alphabetical order, the similar categories will be listed together. For example, all your different vacation folders can have folder names that start with the prefix *Vac*, photos taken at Christmas can be prefixed *Christmas*, and so on. You would decide the prefixes, and also what follows behind them, according to the particular criteria that are important to you – perhaps the theme/place/date, or theme/date/place, and so on. Once you've moved all the new photos to their respective folders you can delete the camera's download folder (e.g. 2006_11_30) for that batch because it would now be empty and no longer required.

In Stage 2 – the sorting stage – each of these event or topic folders should have one or more sub-folders, such as:

- **Originals:** This is the folder into which the original photos are saved when they are transferred from the camera-created folder. (That's what you did with the photos downloaded from our Web site.)
- **Edited:** When you edit photos (crop, enhance colour, etc.) many of the good photo editing programs do not allow you to save over an original picture file. This is a good thing because it protects your originals in their unedited state for future use and perhaps for other forms of editing you may wish to do later. So when you

edit a photo you either need to save the edited version into the same *Originals* folder (not recommended), or save (export) it to a different sub-folder which you could name *Edited* (which is what we recommend).

- **Resized:** If you'll be sending photos by e-mail, or using them as pictures in other documents, on Web pages, etc., you'll first need to resize them to make them smaller. It's useful to keep your resized photos in their own sub-folder named *Resized*.

STAGE 1: DOWNLOADING THE IMAGES FROM THE CAMERA

Setting up a permanent download folder

1. In Windows Explorer (or My Computer), create a new folder inside **My Pictures** and name it **00Downloads To Sort**. (See p11 for the folder creating procedure.)
2. If necessary, in your camera download program, '**register**' that folder as the folder to which downloaded photos are always to be sent. (Refer to the camera software's Help menu or manual to find out how to do this.)

Downloading to the correct folder

3. Each time you're about to download photos from the camera, make sure the destination folder is specified as **00Downloads To Sort**, located inside **My Pictures**; then do the download, following the prompts in the camera's software dialogue boxes.

Viewing thumbnails of the downloaded photos

4. Once all the photos have been downloaded, open **Windows Explorer** (or My Computer in older versions of Windows).
5. Click on **View**, then on **Thumbnails** to display small thumbnail images of a selected folder's contents.
6. Browse to and double-click on the folder named **00Downloads To Sort** in the **My Pictures** folder to open it.
7. Double-click on the new **sub-folder** created by the camera's software for that download and thumbnails of the freshly downloaded photos will be displayed (see opposite).

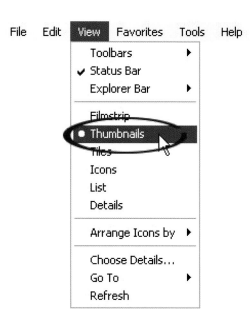

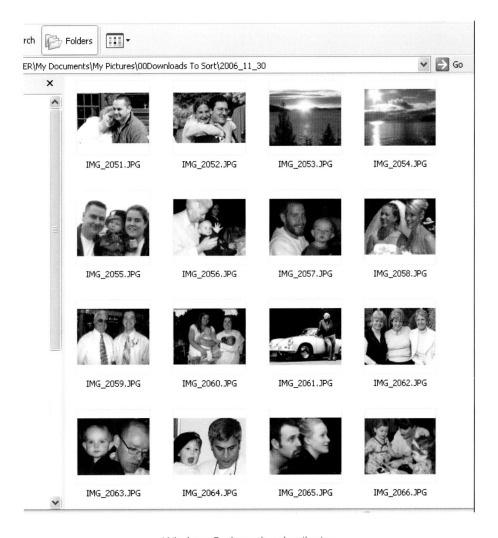

Windows Explorer thumbnails view

STAGE 2: MOVING PHOTOS INTO THEIR EVENT FOLDERS

Some of the downloaded photos may relate to earlier events for which you already have folders, in which case you'll want to move these new photos to the existing folders where they belong. Other photos will be of new events or themes for which you need to create new event folders.

1. Review the thumbnail images to see what events/topics/themes they represent, and write down the names of any new folders you'll need for new events that do not already have their own folder.
2. Create a new folder for each new event. (See p11 for the procedure.)
3. For each of these new folders create a sub-folder named **Originals**.

The next step is to move the photos into the *Originals* sub-folders of their respective event folders.

TIP: DELETING UNWANTED PHOTOS
The best time to delete any unwanted or bad photos from the computer is
before you move them to their event folders.

4. In Thumbnails view in Windows Explorer (or My Computer), hold down the `Ctrl` key and click on each
 photo belonging to the **same event** or theme in order to select it, then release the `Ctrl` key. (Those
 images will now be selected.)
5. Press `Ctrl` + `X` to cut the images for pasting elsewhere.
6. Double-click on the event folder **into which** they must be saved (e.g. Christmas-2006) to open it, then
 click on the **Originals** sub-folder of that event, to select it.
7. Press `Ctrl` + `V` to paste the selected photos into their new home. (Alternatively, you could drag and drop
 the selected images into the Originals sub-folder for that event.)
8. Repeat **steps 4 to 7** for each of the other photo events still remaining in the camera's download folder
 until all the images for all the events have been moved to their permanent **Originals** folders within their
 respective event or theme folders; this will leave the camera's download sub-folder empty.
9. Delete the empty download sub-folder, being sure to leave the main folder **00Downloads To Sort** for the
 next time you wish to download a batch of photos.

If you're likely to download several batches before you have an opportunity
to sort and file them as explained above, then you would have several
camera-generated sub-folders within your folder named *00Downloads To
Sort*, and your folder structure would look something like the example
illustrated here.

Once all your photos have been neatly filed away in the *Originals*
sub-folder of their respective event folders, it's a good idea to rename all
the photos for that event so that each one has the event name as part of
the file name – e.g. Tutorial2.jpg. This can be done laboriously, one by one
in Windows Explorer (not recommended), or you can do them all at once
using a procedure known as *batch renaming* which is offered by most good
photo management programs.

Before we start renaming images using Picasa®, however, we'll need to
make sure we have the six downloaded images in view, with their file
names displayed.

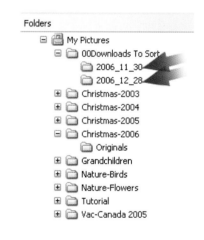

SETTING UP THE APPROPRIATE FOLDER DISPLAY IN PICASA®

1. If Picasa® is not already open click on the **Picasa® shortcut icon** (depicted right) on
 your Desktop to load Picasa®.
2. Click on **View**, and if there is no tick against **Normal Thumbnails**, click on it to select
 that view.
3. Click on **View** again, then on **Sort Folder List By**, then on **Recent Changes** to display
 the **Originals** folder (which should be at the top of the list in the left-hand Folders pane).

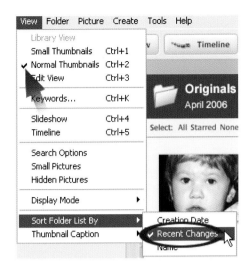

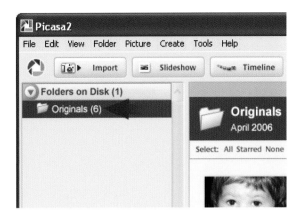

FINDING A FOLDER IN PICASA®

When you open Picasa® the viewing window will probably have more folders and images displayed than just those in the *Originals* folder. If you've followed the steps thus far and moved straight into this chapter, then the *Originals* folder should be at the top of the list of folders in the left-hand pane because the default view in Picasa® is to show the most recent changes first. However, if more images have come onto your computer from a camera or via e-mail since you downloaded the tutorial photos, you may need to do a search to bring the *Tutorial/Originals* folder in view.

NOTE: PICASA® DISPLAYS MULTIPLE FOLDERS

If you have other photos and image files on your computer, stored on your Desktop, or in My Documents or My Pictures, notice how Picasa® is able to display them all in the same thumbnails pane. To view them, simply use the scroll buttons on the right to scroll down through the folders and thumbnails. This cannot be done in Windows Explorer which can display the contents of only one folder at a time.

If the *Originals* folder is not showing in the top row of the main thumbnails pane, this is how you can find it.

1. In the Search window at the top right of Picasa® type the folder name **Tutorial**, and the Tutorial sub-folder named **Originals** will be displayed in the left-hand Folders pane.
2. To return to the normal view, click on the **Exit Search** button on the left.

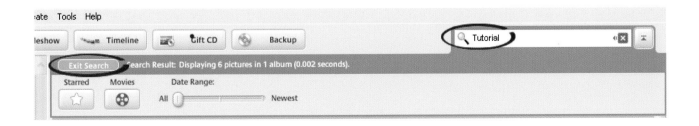

TIP: REMEMBER THIS SEARCH FACILITY

It can come in useful when you're looking for a folder or a photograph.

NOTE: PICASA® DISPLAYS ONLY THE FOLDERS WITH IMAGES IN THEM
Picasa® displays only the folders that contain images, not their hierarchy. So, for example, you won't see the folder *Tutorial* listed because it doesn't have any images in it; the images are all in its sub-folder named *Originals*, so that is the folder that will be displayed.

DISPLAYING THE FILE NAMES

1. To see the current file names of the six photos (IMG_001.jpg, etc.) click on **View**, then on **Thumbnail Caption**, then on **Filename** to select that viewing option (see illustration below left).

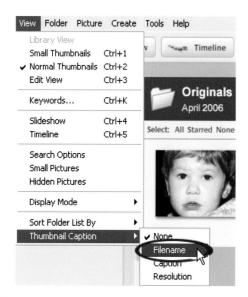

2. Next, on the Menu Bar, click on **Edit**, then on **Select All** (see above right) to select all the images in the folder.

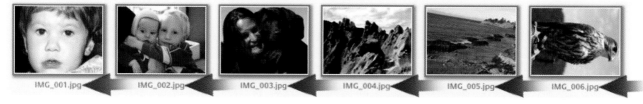

The blue bounding box around each image shows that they have all been selected.
Note that the file names are now showing.

RENAMING A NEW BATCH OF DOWNLOADED PHOTOS

When using the folder management system, some people find it useful to use *batch renaming* to rename all the photos in a particular event folder so that every photo can be associated with its event or theme via its file name. Picasa® makes batch renaming very easy with a feature called *Batch Edit* which allows you to rename a whole batch of photos in one process. Let's do some batch renaming now, using the photos you've downloaded from our Web site. We'll rename all the photos so that each one has the name *Tutorial* as a prefix in its file name.

1. On the Menu Bar, click on **Picture**, then on **Batch Edit**, then on **Rename** (or, with all the images selected, simply press ▦ on your keyboard), and the **Rename Files** dialogue box will open.

2. Type the folder name related to this batch of photos (or 'event'), in this case **Tutorial**.
3. Click on **Rename**.

All your downloaded photos will now be named with the batch name you typed (in this case the folder name *Tutorial*), and with a straightforward numerical reference behind the name.

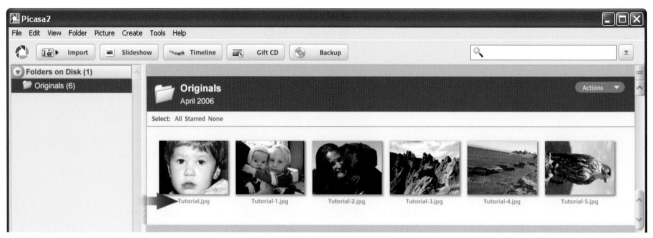

View showing batch-renamed images

NOTE: DELETING A RE-NAMED IMAGE

If you later delete one of the photos, Picasa® will assign that photo's reference number to the next photo and adjust the numerical references of the others accordingly. The new numbers will be displayed when you next open Picasa®, or when you refresh the thumbnails window by right-clicking on the blue bar above the images and then clicking on **Refresh Thumbnails**.

ASSESSING THE FOLDER MANAGEMENT METHOD

As can be seen, the folder management method requires some organizing and preparatory work, but it does help to make sure you remember to review your new photos, delete those you don't want and file the rest away in an orderly easy-to-locate manner for future use.

In Windows Explorer (or My Computer) you can view the contents of only one folder at a time, so one disadvantage of this system is that if you want to find a particular photo you'll need to remember where you filed it. This could be somewhat of a challenge when you've accumulated hundreds or thousands of photos; and this is what makes using image software an attractive option for photo management.

The software method of photo management

Some people find using photo management software to be a far quicker and easier way of saving and finding photos no matter where they are stored on the computer. The philosophy here is that if you have efficient software that will quickly find your photos and display them in whatever categories you choose, what does it matter where they are actually filed on the hard drive?

The problem is, however, that the method of tagging or labelling that is used by editing software usually cannot be transferred (at the time of this book's writing) to other photo editing programs. So if you change your brand of software you'll most likely lose all your search facilities if you don't also have your photos stored in the traditional folder way. This is why many people still prefer to use the folder system as their main library method, with the software system as an extremely useful and speedy sort-and-find method.

The final choice of photo management methodology – folders or software or both – depends of course on the user's preferences and how they intend working with the photos in their photo collection.

For this section on software photo management we'll continue using the Picasa® program. If you later decide to use your camera's own software, or some other brand of photo editing software, then it will be easy enough to make adaptations once you've seen what can be done in Picasa®.

USING 'LABELS' OR 'TAGS' TO FIND PHOTOS MORE EASILY

Many photo programs offer a system of *labels* or *tags* which allow you to display the same image in more than one folder without taking up extra space by duplicating the file on your hard disk. These labels are simply virtual folders used only for search and display purposes.

By using tags or labels you can create any number of virtual folders in your photo editing program so that one photo can be displayed in more than one grouping or event. This is something like having music play-lists, only these are photo-lists or compilations.

We'll now use the six tutorial photos that you saved to your hard drive in the *Originals* sub-folder of the *Tutorial* folder to demonstrate how to add labels to pictures.

1. With Picasa® open, and the **Originals** folder selected, hold down the ⌨Ctrl key and click on the two photos of the children (**Tutorial.jpg** and **Tutorial-1.jpg**) to select both of them. (They will now appear in the Picture Tray at the bottom left of the Picasa® window.)
2. Click on the **Label** button to the right of the Picture Tray, then on **New Label** to open the **Label Properties** dialogue box.

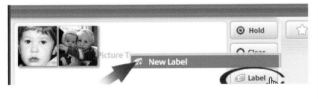

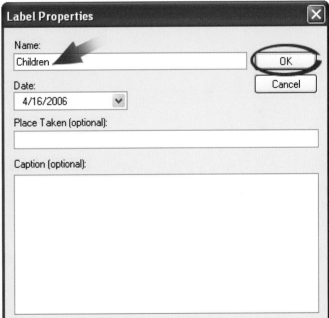

3. In the **Label Properties** dialogue box that opens, type the label **Children** into the **Name:** window, and click on **OK**.

NOTE:
If you wish, you could also add extra information such as the date and
the place the photo was taken, and any other information.

Picasa® will create a new label, called Children, and display the two labelled photos.

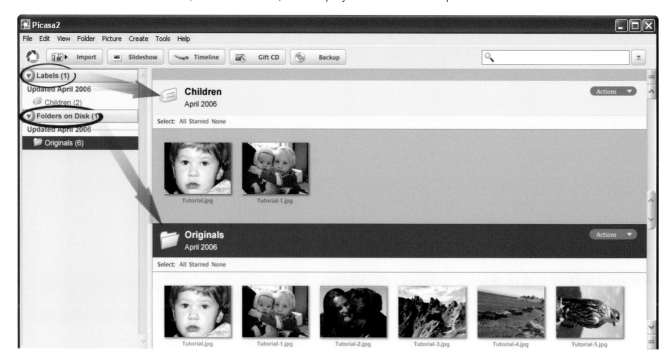

NOTE: LABELS ARE VIRTUAL

Notice the little *label* icon next to the new virtual folder's name in the main panel. This indicates that it is a 'virtual' folder, or *label* – for display purposes only. The image files themselves have not been duplicated and so there has not been an increase in the amount of space taken up on your hard drive. The photos are still filed only in the *Originals* sub-folder of the *Tutorial* folder, which shows a *folder* icon next to the folder's name. The virtual *labels* are also listed separately from the *folders* in the left-hand pane (see above).

ADDING CAPTIONS TO YOUR PHOTOS

Labels apply to the images as they are viewed in Picasa® on your own computer and are a way of finding and viewing images. They are not part of the picture's data file as such. If you want additional information to be embedded into the photo's EXIF (Exchangeable Image File Format) data itself, so that it can be transferred along with the photo when sent by e-mail, posted to a Web page or burned to a CD, you'll need to use what in Picasa® is known as a *Caption*. A caption will remain with your photo wherever it goes.

To add a caption:
1. Double-click on the picture of the two children to view it in Edit mode.
2. Type the following caption and your text will appear in the grey area below the picture as you type:
 Leia and Liam, 2006.
3. Press [Enter] and the caption will take effect.

To hide or show a caption:
1. In Edit view, to hide the caption click on the little white icon to the left of the caption (see next illustration).
2. To show the caption again, click on the white icon again.

To delete a Caption:
1. In Edit view, click on the little grey trash can on the right of the caption. When the **Confirm** dialogue box opens, click **Yes.**

MARKING YOUR BEST PHOTOS WITH 'STARS'

Some photo software allows you to mark or flag your best photos for finding them quickly when you want them. In Picasa® this is called adding *stars*.

1. In Picasa®, hold down the `Ctrl` key and click on several photos in the Originals folder to select them.
2. Click on the **Starred** button in the lower panel and a yellow star will appear in the pictures, and the button's star will turn yellow.

Starred button on

Starred button off

Finding starred photos quickly

1. Click on the **drop-down arrow** to the right of the little **Search** window at the top right of Picasa® to display the Search Options.
2. Click on the **Starred** button on the left to display only the photos with yellow stars on them. (They'll be displayed in all the folders in which they are stored, as well as in the virtual display folders – i.e. *labels*.)
3. To turn off the Starred view, click on the **Starred** button again and Picasa® will display all the photos in all folders, and not just the starred images.

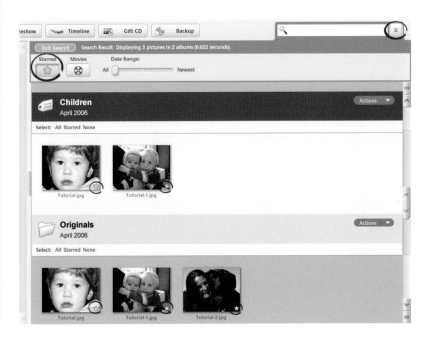

Labelling your starred photos to display them all together

To have all your best (starred) photos displayed together in one virtual folder (*label*) rather than in their individual folders and event labels, you can add a further label to all of them. (This must be done folder by folder.)

1. In the **Select:** line just above the top row of images in the selected folder, click on the word **Starred** and all the starred photos in that folder will be selected as depicted by blue bounding boxes.

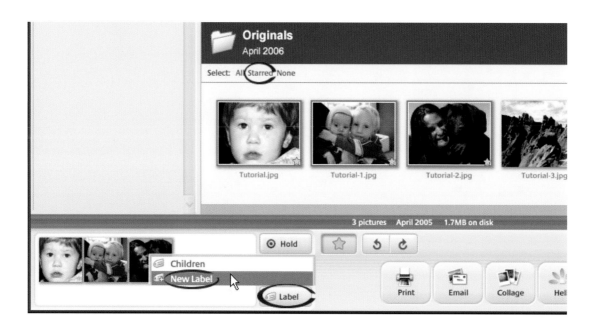

2. Click on the **Label** button to the right of the bottom Picture Tray, then click on **New Label** and type the label's name in the **Label Properties** dialogue box that opens – e.g. *My Best Shots*, or simply *Stars*.

Viewing all your best shots together in one label

To find and view all your best shots together do a search (see p19) for the label *My Best Shots* (or *Stars*, depending on what you named it) and all your starred photos will be displayed together in one label.

TIP: ADDING STARS *AND* LABELS

When you first add stars to photos in a folder it's a good idea to add the *My Best Shots* (or *Stars*) label at the same time. To remove a star, select the image again and click on the **Starred** button; the star will disappear from the picture and the button's star will turn grey again.

REMOVING LABELS FROM PICASA®

You can safely remove labels as well as pictures from labels in Picasa® without deleting the actual image file itself. In preparation for the next chapter, we suggest you remove any labels you've created thus far.

1. Right-click on the blue band of the **My Best Shots** folder to select it.
2. Click on **Delete Label** (or press the ⌦ key). (Be sure **not** to delete the **Originals** folder.)

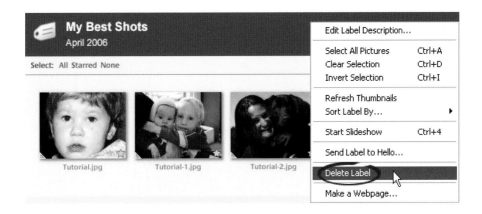

3. When the confirmation window opens, click on **Yes**.

4. Repeat steps 1 to 3 for any other lables you've created (e.g. *Children*).

TIP: REMOVING PICTURES FROM LABELS
To remove a picture from a label, in that label's viewing panel of thumbnails click on the picture to highlight it and press the ⌦ key on your keyboard, and the image will disappear from the label display.

! **If you delete a picture in a label, or even the whole label itself, it is only the display aspect that is removed from Picasa®, not the image file itself. The actual photo file remains on your hard disk where it was saved. However, if you delete a picture from a real folder (e.g. *Originals*), that picture will be deleted from your hard disk. So be very careful when you're about to delete something.**

NOTE: EDITS APPEAR IN ALL VIRTUAL FOLDERS
When you make changes (edits) to a picture that has a label, those changes will be applied to all the virtual copies of that picture in all their virtual label folders, as well as to the picture file you've edited.

Unlike *Captions*, *Labels* are not embedded in the image's EXIF file and they can therefore be used only in the photo editing program in which they were created. They are currently not transferable to other programs or to computers that don't have the same software installed as was used to create the labels in the first place.

So, if you intend switching from one photo program to another at some later stage, any labels you created in the first program will probably no longer apply in your new photo program. This is one of the present disadvantages of many of the photo programs available at the time of this book's going to print. Newer versions of software may well address this problem in the near future.

TIP: RETAINING LABEL GROUPINGS IN OTHER SOFTWARE
If you wish the categories or names of the labels you have created in one program to be available in any other program, you can convert those labels into real folders containing the actual photo files. In Picasa® you would do this by selecting each label in turn, then selecting all the images in that label and exporting them all to a new sub-folder of the same name as the original label. You would locate those new sub-folders somewhere in *My Pictures*, possibly in a new folder named *Former Labels* which would contain a lot of sub-folders each bearing the name of a label you are saving. If you do this, every photo in the new sub-folder will be a new file in its own right, which will take up more space on your hard disk. You might want to consider this option carefully before using it.

KEEPING YOUR PICASA® PHOTO DISPLAYS UP TO DATE

One important advantage of using the software method of photo searching and viewing is that you can view all your images in one display, whereas when viewing thumbnails in Windows Explorer or My Computer you can view only one folder's contents at a time.

Like several other programs, Picasa® can monitor and display every image file on your entire hard drive, or you can specify which folders it should monitor and which it should ignore. Picasa® continuously scans the specified folders and updates its library of images when changes are made to what is on your hard drive. So if new photos are added, or photos are moved between folders or are deleted, Picasa® will pick this up and adjust its display library accordingly. When you downloaded Picasa® you set it to scan and monitor the following folders for changes:

- Desktop
- My Documents
- My Pictures

You could expand this selection by selecting the entire hard disk [C:] for scanning and monitoring for changes, or you can narrow the selection down further. And you can change this again later as needed. Here's the procedure for narrowing down what Picasa® scans, monitors and displays.

NOTE: REMOVING FOLDERS IN PICASA
Removing folders from Picasa®'s viewing tray does not mean they'll be deleted
or moved from where they are currently stored on your computer.
These procedures apply only to what is monitored for display in Picasa®.

1. In Picasa® click on **Tools**, then on **Folder Manager**.
2. In the **Folder List** pane on the left of the **Folder Manager** dialogue box that opens, click on the (+) sign next to **My Pictures** to open it.
3. Next, click on the (+) sign next to **Tutorial** to open it.
4. Next, click on the **Originals** folder to select it.
5. In the right-hand grey panel click on the radio button **Remove from Picasa**; the **Confirm Remove Watched Folder** dialogue box will open.
6. Click on **Yes** and the confirmation dialogue box will close.
7. Back in the **Folder Manager** dialogue box, click on **OK** to remove the **Originals** folder (from being viewed in Picasa®).

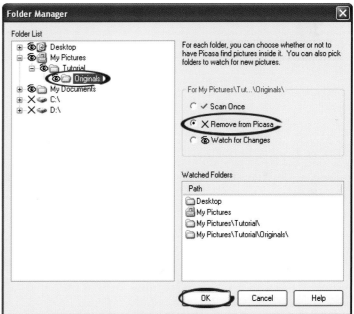

Picasa® will now no longer display any of the images you downloaded from the Web site, although they will still be in the *Originals* folder on your hard drive.

Reinstating the Originals folder in Picasa®

1. Click on **Tools**, then **Folder Manager** and the **Folder Manager** dialogue box will open.
2. In the **Folder List** pane on the left, click on the little (+) plus sign next to **My Pictures** to display its contents, and then click on the (+) plus sign next to the **Tutorial** folder to display its contents as well.
3. Click on the **Originals** folder to select it
4. Click on the radio button **Watch for Changes** on the right, then on **OK**.

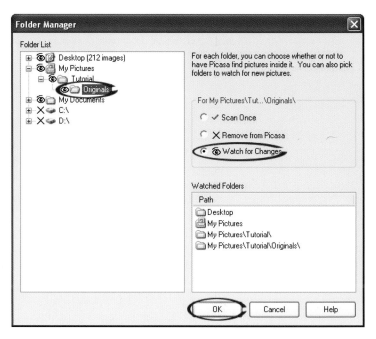

Picasa® will now display the six photos you downloaded to the *Originals* sub-folder within the *Tutorial* folder, and will monitor the Originals folder again for any future changes, and update its thumbnails display accordingly.

This is what you should now see in your Picasa® library window, as well as any other image folders you already had on your computer in the three locations originally selected when you installed Picasa®:

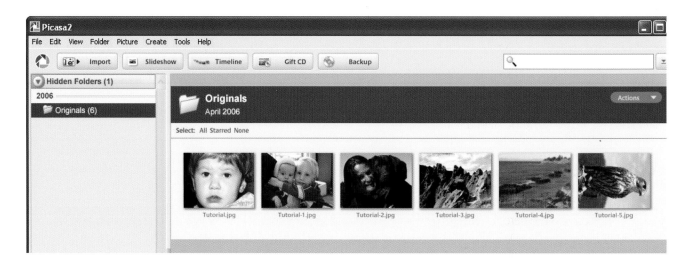

NOTE: PICASA® DISPLAYS ONLY FOLDERS CONTAINING IMAGES
Remember, where images are stored in sub-folders (e.g. *Originals*), and not in the main folder (e.g. *Tutorial*), the Picasa® image library displays only the folder that has the images in it. So in this situation Picasa® displays only the *Originals* sub-folder and its images, not the main *Tutorial* folder as well.

TIP: SELECTING WHICH FOLDERS TO WATCH
When adding folders back to your *Watched Folders* list, bear in mind that there could be images on your hard drive that are not saved inside *Desktop*, *My Documents* or *My Pictures* (e.g. e-mail image attachments that could be filed elsewhere). If you wish to display these images too, then you may need to select the [C:] drive as a watched item as well. Likewise, if you want to limit the folders that Picasa® monitors, then select only those folders you want watched.

LEARN MORE ABOUT PICASA®'S PICTURE MANAGEMENT OPTIONS:
When in Picasa®, press the [F1] keyboard button and, in the Help menu that opens, click on **Organize Pictures** and follow the links.

CHOOSING THE MOST APPROPRIATE FILING AND SEARCH METHODS

Each methodology – folders and software – has its own advantages. Finally, how you manage your photo collection is a matter of preference and depends on what you intend doing with your photos once they're saved on your hard drive. Until new software is released that allows labels and tags to be transferable between different photo programs, we recommend that you set up a proper folder system in Windows Explorer or My Computer as already explained (see pp15–18). Make this your permanent archive. Then use your favourite photo editing program's labels and other features to facilitate your photo finding and management needs as a most useful optional extra.

PROTECTING YOUR PHOTO COLLECTION BY MAKING BACKUPS

It's not often that a house burns down and the occupants lose everything, including their photo collections. But it is very often that computer hard drives 'crash' and one loses all one's data. We cannot emphasize enough how important it is to make backup copies of your digital photo collection. If you don't, and your hard drive fails, you could lose all your valuable photos of family and special events, *everything*.

Another important thing to note is that technology is changing at a rapid pace, and the rate of change is accelerating all the time. VHS video-tapes cannot be played on DVD players. Replacement parts such as lamps cannot be found anywhere for some makes of 35 mm slide projectors or 8 mm movie projectors, so family photos and movies of yesteryear are rendered useless unless you have your old collection transferred to CD or DVD.

Don't let this happen to your digital photograph collection. Floppy diskettes are all but completely phased out. CD-ROM drives will probably soon be replaced by DVD drives. Future computers may not have USB or FireWire ports, which are necessary to connect today's external drives. So, stay vigilant to the changing trends and make sure your photo collection of today will always be accessible tomorrow.

Current backing up options:
• Burning to a CD or DVD, or
• Backing up to an external hard drive, possibly on another computer

Backing up is one area where it's better to be safe than sorry. As CDs and DVDs are prone to corruption and failure, it is advisable, always, to make two backup copies, preferably on two different makes of disk in case the one make had a bad manufacturing batch and both of the CDs fail around the same time. Check the CD or DVD after you have completed the transfer to be absolutely certain your images were copied without corruption. Store one of the backup CDs in a safety deposit box, your office, or any location other than the same location as the other disk.

TIP: BACK UP TO SAVE HARD DRIVE SPACE
If your computer begins to be sluggish due to the vast number of photos stored on the hard drive, back them up on CDs or DVDs. You can now delete old photos from your computer and make room for new ones.

Backing up can be done directly from your favourite CD burning program, or via your photo program. Picasa® offers a useful backup feature:

1. On the Picasa® toolbar click on the **Backup** button and the Backup dialogue box will open at the bottom of Picasa®.

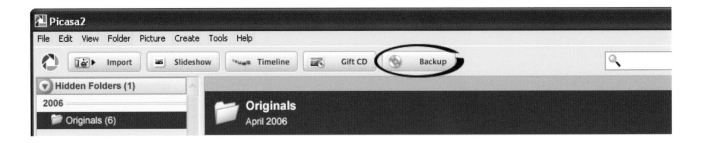

2. Follow the prompts and burn your backup set to CDs or DVDs.

3. For more information on the Picasa® backup options, press ⌨ and on the **Contents** tab of the Picasa® Help menu, click on **Backup Pictures**.

 It is vitally important that you maintain regularly updated backup copies of your digital photo collection. Do this from the very beginning.

Also, don't leave your backup sets lying in some drawer for years, only to find out too late that the technology has changed and your backup files can no longer be accessed by the computers of the day. Stay abreast of technology and make sure you update how you keep your backups so that they always remain accessible and readable.

TIP: BACKUP WHAT'S IMPORTANT
You may want to add a label or star to all your valuable photos and back up only those photos each time you do a backup. You'd simply search for all your stars to view them all in one folder, then select them all and export (save) them to a rewritable CD.

Basic photo editing 3

OVERVIEW
In this chapter you'll learn some basic photo editing techniques such as:

- Reducing red-eye - reducing the red one often sees in a subject's eyes
- Cropping - retaining the parts of an image you want to use and discarding the rest
- Lightening - making a dark image lighter
- Sepia - changing the colour to sepia tones
- Straightening - where a photo was taken a bit askew and you want to straighten it
- Rotation - rotating a photo so that it displays the 'right way up'
- Resizing - altering the physical size of a photo for e-mailing, printing and other purposes
- Other special effects - sharpening a slightly blurred image, softening an image, intensifying colour, converting to black and white, and so on

We'll be using Picasa® for the editing. So open Picasa® to start the exercises.

1. In the folders list click on the **Originals** sub-folder to view the six photos you downloaded from our companion Web site (see p13).

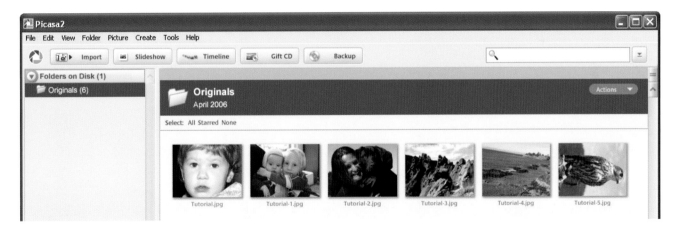

REDUCING 'RED-EYE' IN A SUBJECT'S EYES
Most eyes are prone to producing a 'red-eye' effect when the flash is used. This occurs because built-in flash units are so close to the lens of the camera. Red-eye ruins an otherwise beautiful photo if it's not corrected.

1. In Picasa®, click on the **Originals** folder to show its contents in the thumbnails pane.
2. Double-click on the image **Tutorial.jpg**, the child with red-eye, to open it in Edit Mode.

3. In the left panel, click on the **Basic Fixes** tab if it's not already selected, then click on the **Redeye** button to open the **Redeye Repair** box.
4. In the photo itself, click just outside and above the red pupil of the eye on the left, hold down the mouse button and drag the pointer down and to the right to select the entire red area, taking care that there is no red outside the selection box.
5. Release your mouse button and wait a second or so for the red to magically disappear.
6. If you missed some of the red, click on the **Reset** button and try again.
7. Once you're happy with the left eye, select the right eye and repeat the procedure to correct that one as well.

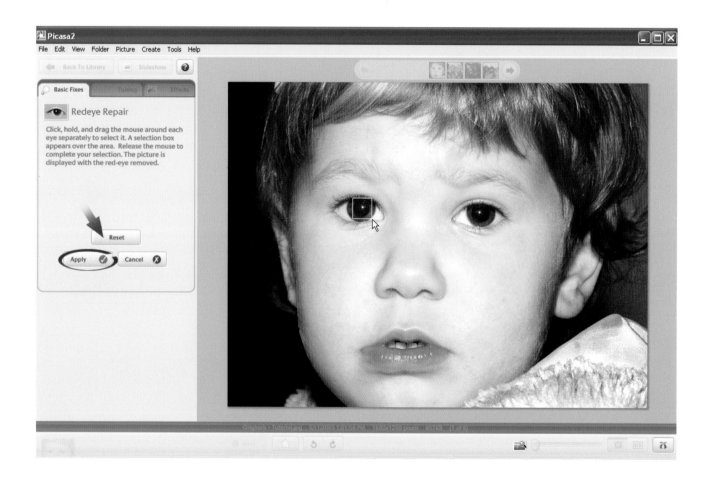

8. When done, click on the **Apply** button to accept the changes. (These changes are not saved permanently and are undoable at any time, unless you save a copy of the edited image.)
9. Click on the **Back To Library** button to return to the thumbnails.

SAVING THE CHANGES YOU'VE MADE

 With some photo editing programs, like Picasa®, it is impossible to save over an original file. The original photo is protected as if it's a 'digital negative' and every edit you make is fully reversible on the original. The only way to save changes you've made is to save a copy of the edited picture, either in its existing sub-folder (not recommended) or by exporting it to a new sub-folder.

NOTE: USING EDITED IMAGES IN OTHER PROGRAMS
If you wish to use an edited version of a picture in a different program, such as MS Word, then you *must* export a copy of it in order to save it. Otherwise the picture you'll be working with in the other program will show up in its unedited state.

Rather than clutter your *Originals* folder with copies of edited versions as well as the originals, it's better to make a separate folder in which to store your edited pictures. In Picasa® this is done with the *exporting* procedure.

1. Click on the image **Tutorial.jpg** that you've just edited to select it for exporting and saving.
2. Click on the **Export** button found at the bottom of Picasa® and the **Export to Folder** dialogue box will open.

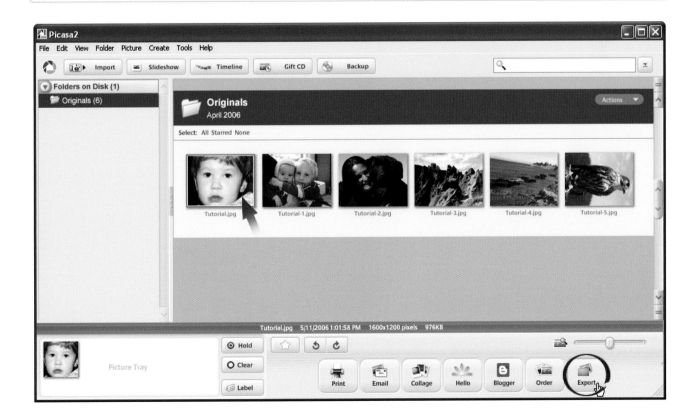

In the **Export to Folder** dialogue box, under **Location of exported folder:** the folder hierarchy should show **My Pictures\Tutorial\Originals** (**Originals** being the folder in which you've made your 'photo selections'). If it doesn't, you'll need to change the location accordingly:

3. Click on the **Browse** button to open the **Browse For Folder** dialogue box, then browse to the folder named **Tutorial** and click on it to select it.
4. Click on **OK**.

5. In the **Name of exported folder:** window of the **Export to Folder** dialogue box, replace the word Originals with **Edited**.
 (Note: My Pictures\Tutorial**Originals**\ in the top window changes to My Pictures\Tutorial**Edited** (**Edited** being the name of the new folder we're creating that will contain all the edited images).
6. Under **Image Size Options:** click on the **Use Original Size** radio button (if this size is not already selected).
7. Under **Image Quality:** click on and pull the slider to 100% (if not already at 100%).
8. Click on **OK**.

A copy of your edited red-eye reduced photo will be placed in your new folder called *Edited*, in the same size and quality as it was when downloaded to the *Originals* folder. This is a real copy saved on your hard disk, and not a virtual copy.

NOTE: SAVED VERSUS UNSAVED EDITS
Although the original photo of the little girl with red-eye appears corrected in Picasa's® *Originals* folder, if you use Windows Explorer to view the photo in the *Originals* folder in thumbnails view it will still be displayed *with* red-eye, because that is not the *saved* version. However, if you view the copy in the *Edited* folder, that one will display the red-eye correction because that is the *saved* version of the edited picture. This should help to clarify how this system of editing and saving works in practice.

You will now have the following displayed in Picasa®:

- your original photo, with the red-eye correction, in its *Originals* sub-folder within the *Tutorial* folder, still *displayed* (but not saved) in its corrected view, and
- the red-eye corrected *copy* in the *Edited* sub-folder within the *Tutorial* folder, saved in its new, corrected view.

Changing the original picture back to its unedited state

If you want to return the original picture in the *Originals* folder to its unedited state, you can do this by undoing all the edits you've made to it. (This is not essential, but it's worth knowing how to do this in case you later wish to make different edits to the original photo *Tutorial.jpg*.)

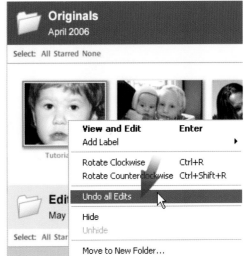

1. In the left-hand pane of Picasa® click on the **Originals** folder to select it.
2. **Right**-click on **Tutorial.jpg**, the picture of the child that you've edited.
3. In the menu that opens click on **Undo all Edits**.
4. In the **Confirm** dialogue box that opens, click on **Yes**.

5. In the second **Confirm** dialogue box that opens, again click on **Yes**.

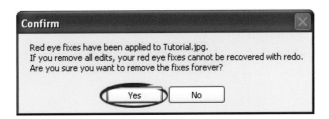

RELAX! THE CHANGES ARE NOT LOST FOREVER!

Don't panic at the question, "...remove the fixes forever?" This simply means that you won't be able to 'Redo' those edits again by using any Redo buttons in Edit mode. You will, however, be able to do the same edits again from scratch, if you want to.

CROPPING A PHOTO

Often you'll find there's superfluous content in a photo, and you'll want to cut out some of it to better feature the main subject. This is called *cropping*. Also, some photos just beg to be cropped to obtain a better view of the main subject, especially when the subjects have flawless, perfect skin like children do.

TIP: AVOID SEVERE CROPPING IF POSSIBLE
Extensively cropping of a photo significantly reduces the image's physical size, so be aware that you may lose the ability to reproduce the photo as a 12 x 18cm (5 x 7in) or 20 x 25cm (8 x 10in) good-quality print.

1. In the thumbnails pane of the **Originals** folder, double-click on the image **Tutorial-1.jpg,** the two children, to open it in Edit view.

2. Click on the **Basic Fixes** tab on the left, then click on the **Crop** button to open the **Crop Picture** panel.
3. Click on the radio button **5 x 7** to crop the image to a finished size of 12 x 18cm (5 x 7in); (you could select any size or manually size it to your own dimensions by clicking on the Manual button.)
4. Click on the photo at a starting point just left of and above the head of the baby and drag the mouse pointer diagonally down to the right.

As you drag the pointer, the crop area will automatically assume the ratio of 5 x 7 or 7 x 5 and will remain light while the area to be cropped away will appear shaded.

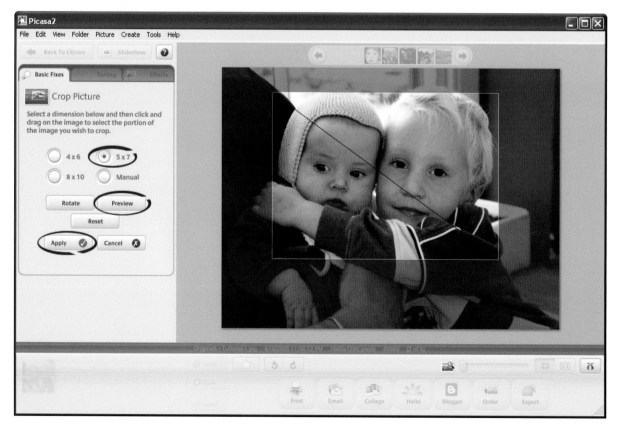

5. Once the desired area is framed in the **Crop Picture** panel on the left, click on the **Preview** button to see what the cropped picture will look like; the photo will revert to the full edit view after a few seconds.

6. If the crop selection area is not the size you want, click on and **drag** the **border line/s** outwards. (The crop selection will retain the 5 x 7 or 7 x 5 proportions no matter how you drag the border lines).

7. If the lighter crop area is not positioned quite where you want it, **click inside the lighter area** of the photo, hold down the mouse button and drag the entire 'crop' selection to a better position.

8. Once you're happy with the crop area, click on the **Apply** button and the photo will be cropped.

9. If you're not happy with the crop, click on the **Undo Crop** button and then on the **Recrop** button to start again.

10. When done, click on the ⬛ Back To Library ⬛ button to return to the thumbnails view.

11. To save the changes, follow the exporting procedure set out earlier under the heading **SAVING THE CHANGES YOU'VE MADE** (see pp35–37).

TIP: CROP BEFORE EDITING

For best results it's advisable to do any required cropping of a picture first,
before editing it with any of the other editing tools.

LIGHTENING A DARK PHOTO

Sometimes the perfect shot happens so quickly that we don't have time to set up our cameras. So we just snap the photo as fast as we can so as to not miss the shot, and then worry about correcting the image later – one of the advantages of going digital.

1. Double-click on the image **Tutorial-2.jpg**, the picture of the girl and her dog, to open it in Edit mode.

l-1.jpg Tutorial-2.jpg Tutoria

Both the dog's expression and the girl's face are lost in the darkness of the photo due to extreme backlighting and no fill flash.

1. In Edit mode, click on the **Basic Fixes** tab.
2. Click on and move the **Fill Light** slider to the right to about **75%**. You will see an immediate improvement in the photo.

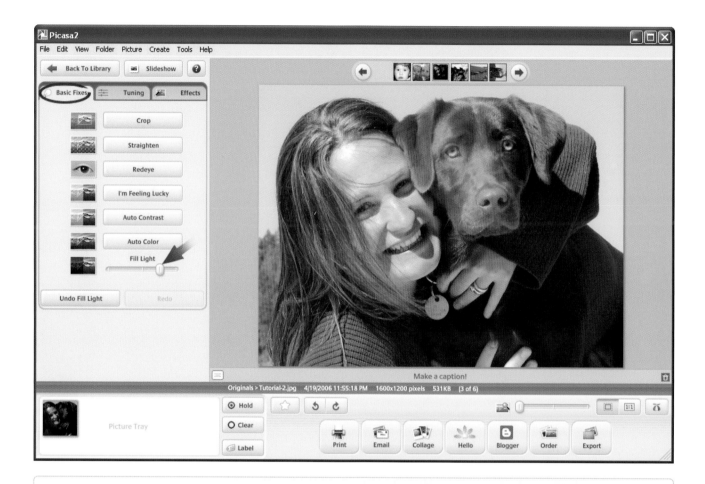

3. Click on the ◀ **Back To Library** button to return to the thumbnails view.
4. Export the edited picture to the **Edited** sub-folder as explained on pp35–36.

CONVERTING A PICTURE TO SEPIA TONE

Sometimes a scene can be made more dramatic by changing it from colour to a sepia tone which creates an antique-looking brownish hue.

1. **Double**-click on the image **Tutorial-3.jpg**, the picture of the rock formation, to open it in Edit mode.

2. Click on the **Effects** tab, then on the **Sepia** effect icon; notice the change.
3. Now click on **Sharpen** to sharpen the detail a little, and notice the photo changes again.

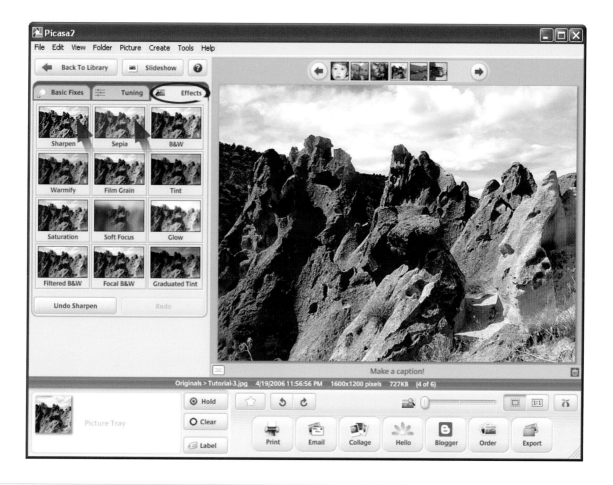

4. Click on the |◀ Back To Library| button to return to the thumbnails view.
5. Export the edited picture to the **Edited** sub-folder as explained on pp35–36.

STRAIGHTENING A SKEWED PICTURE

1. **Double**-click on the image **Tutorial-4.jpg**, the picture of the coast and ocean, to open it in Edit mode.

2. Click on the **Basic Fixes** tab, and then on the **Straighten** button to bring up the **Straighten** image slider panel.

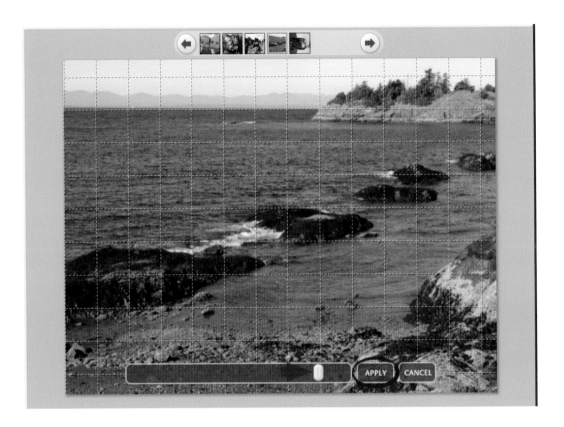

3. Click on the grey slide button, hold the mouse button down and slide the grey button to the right to straighten the picture.
4. When the ocean's distant edge lines up with the horizontal grid lines, click on the **Apply** button.
5. Click on the ◄■ Back To Library button to return to the thumbnails view.
6. Export the edited picture to the **Edited** sub-folder as explained on pp35–36.

When straightening a photo, the pixels in your image (the tiny building blocks of the image) are shuffled around and some may actually be eliminated. If the most valuable aspect of your photo is at the very edge of your picture, be aware that you may lose that part of the picture that was most important to you. Extreme straightening also causes some loss of photo quality. Try not to be too aggressive with the straightening tool.

ROTATING PHOTOS

Whenever photos are downloaded from the camera they are saved to the computer in a horizontal view (unless you are using a photo program that automatically rotates your photos to their proper position). So if a photo is taken vertically (often referred to as *portrait* view), when it is saved to the computer it will be displayed as if it's lying on its side. Because the hawk was photographed vertically it will therefore need to be rotated 90° to the left (or counter-clockwise) so that it is viewed the 'right way up'.

1. In Picasa®, click on the **Originals** folder to show its contents in the thumbnails pane.
2. Click on the image **Tutorial-5.jpg**, the image of the hawk, to select it, and a small thumbnail image will appear in the Picture Tray at the bottom left of the Picasa® window.)
3. Click on the ↺ **Rotate counter-clockwise button** located below the thumbnails pane and the selected image will rotate 90° to the left to display the right way up.

Tutorial-4.jpg Tutorial-5.jpg

NOTE: ROTATION IS IN 90° STEPS

Notice that the *Rotate* buttons can rotate to the left or to the right, at 90° for each click. Experiment with these buttons to see the effects. Some photographers turn their cameras to the right when taking vertical shots, so they would use the counter-clockwise button to rotate the image. If the camera was turned to the left, use the clockwise rotate button.

TIP: ROTATING SEVERAL IMAGES TOGETHER

Where there are several images in a batch that need to be rotated in the same direction, you can do this in one process. Hold down the Ctrl key and click on each image that is lying on the same side, to select them all. Then click on the applicable *Rotate* button and they'll all be rotated together. If you have other pictures that need to be rotated in the *opposite* direction, repeat the process using the other *Rotate* button.

4. Click on the ⬅ Back To Library button to return to the thumbnails view.
5. To save the changes, follow the exporting procedure set out under the heading **SAVING THE EDITS YOU'VE MADE**.

EXERCISE: USING OTHER EDITING TOOLS

You can add more than one effect to the same picture. Use the tutorial photos to experiment with the various editing tools in Picasa®.

TIP: SOME EFFECTS ARE BEST USED TOGETHER
Some of the editing effects are best used in conjunction with another effect. To find out more about the various editing tools and how they can be used to modify an image, press the [F1] to open the Picasa® *Help* menu and in the *Contents* menu click on *Edit Pictures*.
Read the explanations given there and browse through the clickable links.

Some examples of multiple edits done

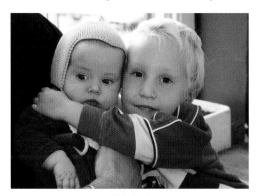

Original

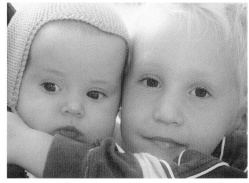

Tint, Glow, Crop 6 x 4, Sharpen

Manual Crop for panoramic view, Glow, Soft Focus. (Looks unimpressive here, but when printed quite large, framed and mounted on a wall, a picture like this can look very striking.)

Original

Manual Crop, Rotate (Rotate can also be used to provide a 'tilt' to a straight photo), Saturation, Film Grain, Sharpen twice.

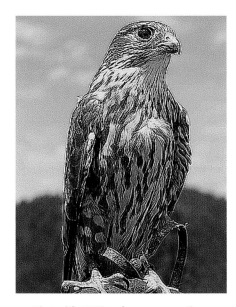

Tint with 50% colour preservation, Filtered black and white, Sharpen four times.

Original

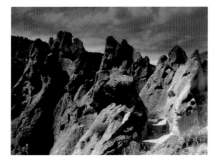
Graduated Tint

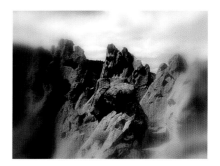
Soft Focus, Black and White, Sharpen

RESIZING PHOTOS

Some editing programs, like Picasa®, and certain e-mail programs and operating systems, have an e-mailing feature that automatically offers to resize an image before it is attached to an e-mail. But sometimes you may wish to resize all or some of your images anyway, either for e-mailing later or for other reasons such as Web design or inserting into newsletters.

Here's how you do it in Picasa®. (As you would probably want your *edited* pictures resized, rather than the originals, for this tutorial we'll resize all the edited images that have been saved to the *Edited* folder.)

1. In the folders pane on the left, click on the **Edited** folder to select it.
2. Press Ctrl + A to select all the edited images. (Or right-click on the broad blue **Edited** bar above the thumbnails, then click on **Select All Pictures**.)
3. With all the photos selected, click on the **Export** button at the bottom of Picasa® and the **Export to Folder** dialogue box will open.
4. In the **Export to Folder** dialogue box, check under **Location of exported folder:** to see if it shows the folder hierarchy as **My Pictures\Tutorial\Edited** (**Edited** being the folder from which you've made your 'photo selections').

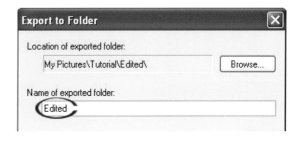

5. If it doesn't, click on the **Browse** button to open the **Browse for Folder** dialogue box, browse to the folder **Tutorial**, then click on it to select it.
6. Click on **OK**.

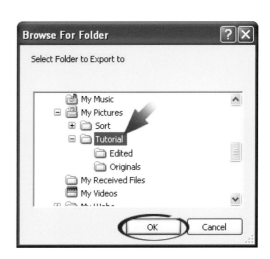

7. In the **Name of exported folder:** window replace the word Edited with the word **Resized**. (Note: My Pictures\Tutorial\ **Edited**\ changes in the top window to My Pictures\ Tutorial**Resized** (**Resized** being the name of the new folder we're creating that will contain all the resized images).
8. Click on the radio button **Resize to:**
9. Under **Image Size Options:** move the slider to the extreme left to indicate that the images will be resized from 1600 down to **320** pixels.
10. Under **Image Quality:** move the slider to the right to change the **Image Quality:** to no less than **80%**. (Anything less will be a poor-quality resized image. We have selected 85%.)
11. Click on **OK** and the images will be resized and saved in the new **Resized** folder.

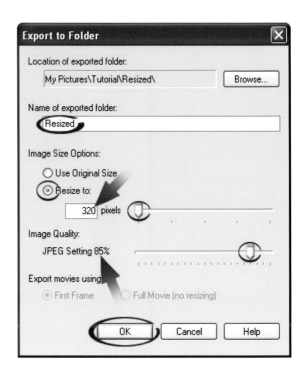

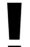 These resized, low-resolution photos are no longer appropriate for printing. Use only the high-resolution images in your *Originals* or *Edited* folders to get the kind of quality necessary for a crisp print.

Seeing the image resolutions

To see the two different image resolutions of the photos in the *Edited* folder compared with those in the *Resized* folder:

On the **Menu Bar**, click on **View**, then on **Thumbnail Caption** and then on **Resolution**.

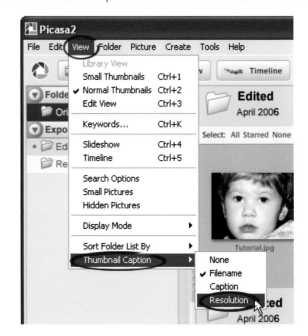

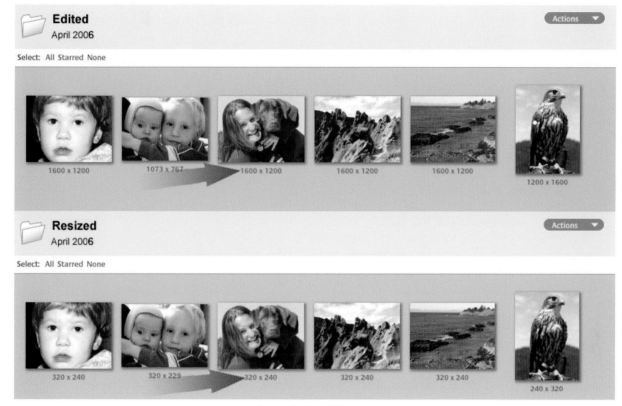

The resolution differences

The photos in the *Resized* folder are now small enough for e-mailing and for use in other programs. Your folder structure should now look like this:

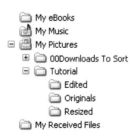

Making use of your photos 4

OVERVIEW

In this chapter you'll learn how to make use of your photos in various ways:
- Printing your photos
- Sending photos by e-mail
- Inserting photos into Word documents (e.g. newsletters, business presentations)
- Creating PowerPoint slide presentations that include photos
- Publishing your photos on a Web site for others to see or download
- Creating a collage of photos for albums and displays

 For ease of explanation and learning, we'll continue making use of the Picasa® software which makes most of these tasks very easy. Obviously, if you already have or later acquire a different photo management program that you wish to use, you can adapt these procedures accordingly. But for now we suggest you work in Picasa®.

PRINTING YOUR PHOTOS YOURSELF

Printer and paper requirements

If you have a good colour printer you'll no doubt want to print your digital photos yourself. A photo printer will print good quality photos as well as do text printing. Not all text printers, however, produce excellent quality photo prints. Inkjet printers are quite adequate for printing colour photos provided they are not at the bottom end of the price range. If printing your photos yourself is going to be an important aspect of your digital photography then it's wise to invest in a good quality photo printer.

It's best to use the glossy or matte photo paper specially developed for printing photos with computer printers. This paper is readily available from printer manufacturers as well as camera and computer supplies stores.

Knowing the quality/size of your photos

For printing (and for certain other procedures) it's a good idea to set the view in your thumbnails display so that you can see the resolution (quality/size) of each photo in all folders.

1. In Picasa®'s Menu Bar, with the images from the Originals folder displayed in the thumbnails pane, click on **View**, then on **Thumbnail Caption**, then on **Resolution** to select the view that shows the resolution below each photo.

Printing from the software program

As with resizing, with printing it makes sense to print the photos you've already edited, so we'll be selecting pictures in the *Edited* folder, not the *Originals* folder. And, as we've said, images that have been resized to a smaller size won't make good prints.

1. In the Edited folder, click on the first image to select it, as indicated by its blue border.
2. Click on the **Print** button below the thumbnails pane and a new viewing layout will be displayed.

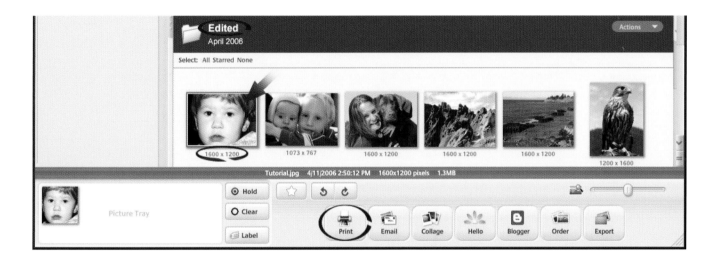

3. In the **Print Layout** panel on the left (see next page), click on the layout you want to use for your printed page. For the tutorial, we've used the **Wallet** layout.

NOTE: U.S. PROGRAMS MOSTLY USE IMPERIAL MEASURMENTS
Picasa® uses imperial measurements and US paper sizes, 8.5in x 11in being the most common. Standard A4 paper measures 210 x 297mm (8.3in x 11.4in).

4. At the last option of the left panel (**Copies per picture**) click on the (**+**) plus sign repeatedly until it says **9 copies**; nine copies of your selected photo will now be displayed in the **Preview** panel.

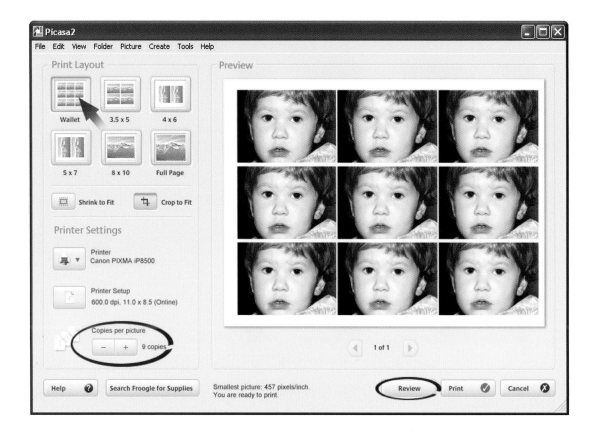

5. Click on the **Review** button below the nine images and the **Review for Printing** dialogue box will open.
6. Check that it tells you that you have the **Best Quality** for printing the size you've selected.
 It will also tell you how many pixels per inch (ppi) are in your photo. Click on **OK**.

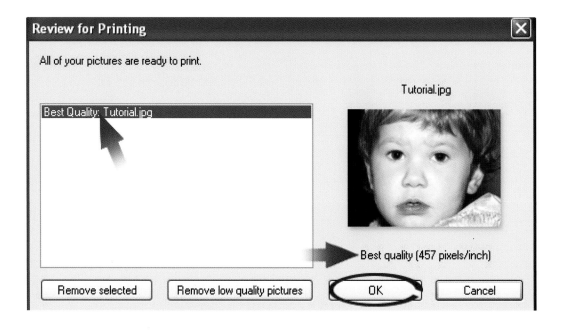

7. If the **Review** button shows an alert symbol (this may occur if you mistakenly selected one of your resized images or any other low resolution images on your computer), click on it to see what the resolution is of the image you selected, so that you can rectify it.

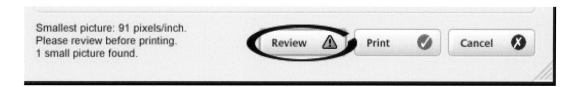

NOTE: DON'T PRINT LOW-RESOLUTION IMAGES
If the pictures you've selected for printing are those in the *Edited* or *Originals* folder, then they will still all be high-resolution images suitable for printing. The procedure for correcting the resolution is shown here in case you later have low resolution versions of photos on your computer. These steps will show you how to deal with it.

This example of a typical message in the *Review for Printing* Dialogue Box tells you that you've selected a very low resolution photo which is not appropriate for quality printing. It also shows you the low number of pixels per inch (ppi) there are in your photo, making it a bad choice for printing.

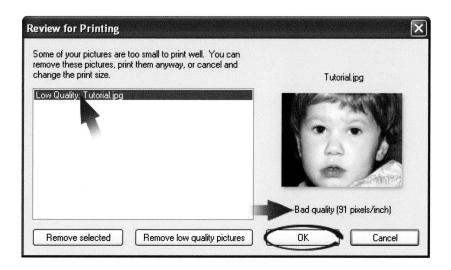

8. Click on **OK** and return to the thumbnails pane in Picasa®.
9. Select a high-resolution image (one from your **Edited** or **Originals** folder) that is more suitable for printing.

TIP: IMAGE RESOLUTION FOR GOOD PRINT QUALITY
If you're printing in sizes 3 x 5 or even 4 x 6 then an image resolution of 72 ppi might be a reasonable resolution. If printing anything larger, the acceptable image resolution is 150 ppi, even better at 300 ppi. Fortunately Picasa® alerts you if the resolution is considered too low for good quality printing.

Once you've established that the image is of a high enough resolution for good quality printing, set up your own printer, as follows:

10. Click on the **Printer Setup** button in the **Printer Settings** section of the panel.

A window will open displaying the properties of your own printer.

11. For **Media Type:** click on the drop-down arrow to select the type of paper you will be using. (Check the box or wrapper your photo paper came in to confirm the type of paper you need to select in your **Printer Properties Media Type**.) We have selected Matte Photo Paper which is actual photo paper and not photo 'quality' paper which is a much lighter paper (albeit a good quality surface) than the heavier paper used for photographs.
12. Click on **OK** and the printer's Properties dialogue box will close.

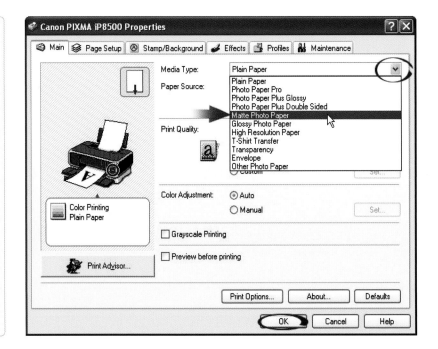

NOTE: SELECT MATCHING PAPER AND PRINT QUALITY
Printers are usually set by default to print at low (or Standard) quality, which is fine for printing text documents on plain paper but not good enough for printing photos on photo paper. When you select *Glossy* or *Matte Photo Paper* as the Media Type, your printer should automatically adjust the Print Quality to *High*. If it doesn't, click on the radio button **High** (sometimes referred to as **Best** or **Photo**, depending on the make and model of printer) to ensure that you're using the high-quality print feature in conjunction with your high-quality photo paper rather than the default Standard which will give you just that – a standard print versus a high-quality print.
Media type is a personal choice. Inks on Glossy Photo paper sit on the surface, enhancing colour saturation, contrast and sharpness. Matte papers, on the other hand, absorb the inks and reduce the vibrancy of colours and contrast, giving a more subdued look. Both papers produce good results. There is no point in printing at a high print-quality if you're using plain paper – you will end up with a soggy mess.

A window will open to indicate that the information you have selected is being sent to your printer.

13. Make sure you have inserted the correct paper into your printer.
14. Click on **Print** to print a page of your wallet sized photos with the current printer settings.

TIP: INSERTING THE PAPER RIGHT SIDE UP
It is important to print on the correct side of photo paper or you'll waste expensive inks and papers. If you're unsure about the correct paper orientation with your printer, mark one side of a plain sheet of paper with a big **X**, to represent the right (glossy or matte) side of the paper you will be using. (Remember which way you inserted it into your printer!) Then select **Plain Paper** for Media Type, click on the radio button **Draft**, and select **Grayscale Printing**. Print a short piece of text that requires only a small amount of ink.
Once you've established the correct way to insert the paper, select high quality for both the paper type and the print quality and then print your photos.

Printing two copies of four different photos, all on one page

Picasa® makes it very easy to print up to nine different photos on one sheet of paper or two (of up to nine).

1. Hold down the Ctrl and click on two of the photos from the **Edited** folder that you wish to print. (They will be highlighted with a blue border.)
2. Click on the **Print** button below the thumbnails pane.

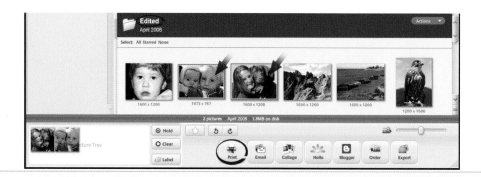

3. In the Print Layout panel that opens, click on the icon to select size **3.5 x 5** (see p52).
4. At the **Copies per picture** option below that, click on the plus (+) button once to change it to **2 copies** so that you have two copies of each photo showing in the **Preview** pane.

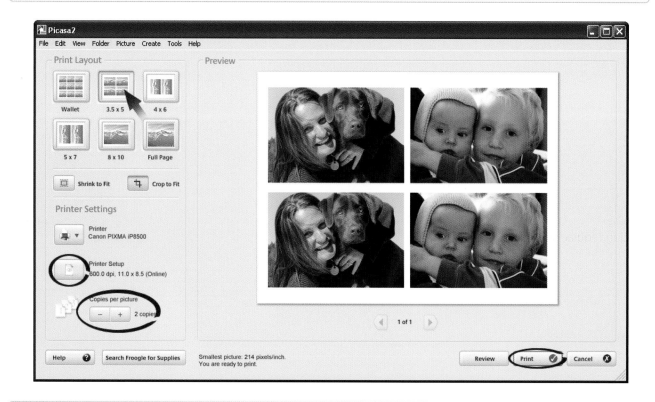

5. Click on the **Printer Setup** button just above that to confirm that your earlier high print quality settings still apply in the **Printer Properties** dialogue box, then click on the **Print** button to print your images.

NOTE: STREAKY PRINTS

If your printed photos have wide streaks (called *banding*), the print-heads on your printer may need to be cleaned or aligned. Follow your printer's procedure to do this.
(This problem should not occur where the print-heads are an integral part of the ink cartridges you purchase, which is the case with some makes and models of printers.)

TIP: GETTING THE BEST QUALITY PRINTS

There is an on-going debate about whether home printers can print photos that will stand the test of time. If you want high-quality, long-lasting prints, consider upgrading to a dedicated photo printer (costs have reduced drastically over the past few years) or using a photo printing service.

USING A PHOTO PRINTING SERVICE

If you don't have a suitable colour printer there are several other options available to you.

Your local photo processing store

Discuss your needs with a photo service and find out how they want you to supply them with the images you need printed. Here are two possibilities:

- Burn them to a CD or DVD and drop these off at the store.
- Upload the images to the store's own Web server per their procedure.

TIPS: SELECT THE EDITED PHOTOS FOR PRINTING

Before you take any photos in for printing, first complete all edits so that what you have printed is exactly what you wanted. Prepare the photos using photos taken with the highest resolution your camera offers. A 2 to 3 mega-pixel camera will not produce good quality large prints but is okay for small prints.

Internet photo processing services

There are several online services that will print your digital photographs on the same silver-based paper as used for printing regular film prints.

1. Open your Web browser (e.g. Internet Explorer, Netscape, Firefox, Opera, etc.).
2. Use your favourite search engine to do a search for **online photo processing + your own country** to find out what services are available and what they require in terms of sizing, resolution, payment, etc.

TIP: CHOOSE A REPUTABLE SERVICE

Satisfy yourself that they are a reputable company before submitting your credit card information on any Web site.

SENDING PHOTOS BY E-MAIL

When sending photos by e-mail you should send smaller versions than the originals that came off your camera. The reason for this is that large files take a long time to transmit, and some Internet service providers block e-mails with large files.

A good size for sending one or two pictures is 640 x 480 pixels. If you are sending more than two in one e-mail, a size of 320 x 240 pixels would be appropriate.

TIP: SENDING VERY LARGE FILES

If you need to provide large files to someone, like a graphic design house or a printing company, then it's best to provide them with your photos on a CD, hand-delivered or by post.

There are several ways to send photos by e-mail:
- open your e-mail program and attach the files to a new e-mail
- send the file from Windows Explorer (or My Computer)
- use your photo management software to do it for you.

Method 1: Sending from your e-mail program

If you use this method you must first make sure the photos you wish to send have already been resized to around 640 x 480 pixels and saved to a *Resized* folder.

1. Open your e-mail program (e.g. Outlook Express or Eudora).
2. Create a new e-mail letter.
3. Click on the **Attach** icon to attach the picture file of your choice.
4. Browse to the applicable **Resized** folder and, while holding down the `Ctrl` key, click on each image you want attached to the e-mail.
5. Click on the **Attach** button in the **Attach File** dialogue box, and the files will be attached to your e-mail ready to be sent.
6. Address your e-mail and type the subject and content as usual, then send the mail to the recipient.

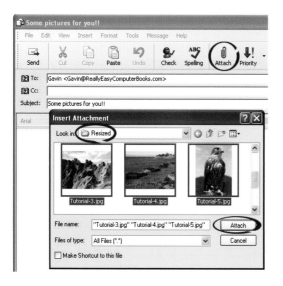

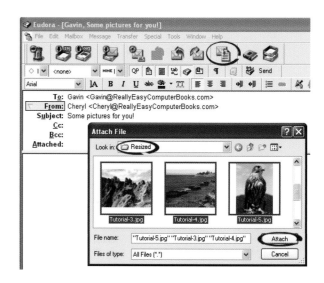

Method 2: Sending pictures from Windows Explorer (or My Computer)

With this method too, make sure the photos you'll be sending have been resized to around 640 x 480 pixels and saved to a *Resized* folder.

1. In Windows Explorer set the view to **Thumbnails** so that you can be sure you're selecting the correct pictures you wish to send by e-mail.
2. Hold down the Ctrl key and click on the image files to select those you will be e-mailing.
3. Hold your cursor over one of your selected images, then **right-click** the mouse button and in the menu that opens point to **Send To**, then click on **Mail Recipient**, and your default e-mail program will then open a new e-mail with the file(s) attached.
4. Insert the recipient's details and the subject, and type your message; then send the e-mail in the normal manner.

Method 3: Sending pictures from Picasa®

When you wish to e-mail a photo that has not already been resized, Picasa® will resize it for you automatically and send it straight to your e-mail program as an attachment, ready to be sent. First you need to configure the options for your specific e-mail program.

1. On the Menu Bar in Picasa®, click on **Tools**, then on **Options** to open the **Options** dialogue box.

2. In the **Options** dialogue box click on the **E-Mail** tab.
3. Under **E-Mail Program** click on the radio button for the program you normally use (e.g. Outlook Express, Eudora).
4. Click in the check box against **Let me choose each time I send pictures**.
5. In the **Output Options** section, under **When sending more than one picture, resize to:** move the slider to **480 pixels**.
6. Under the next option **When sending single pictures, resize to:** click on the radio button **480 Pixels as above**.
 Click on **Apply**, then on **OK** and you'll be returned to the main window of Picasa®.

7. Hold down the |Ctrl| key and click on three of the photos from the **Edited** folder that you wish to attach to your e-mail or press |Ctrl| + |A| to select them all.

The selected photos in the *Edited* folder should now have a blue bounding box to indicate they've been selected. Small thumbnails appear in the Picture Tray at the bottom left to indicate which photos have been selected for attaching to the e-mail.

8. In the panel to the right of the Picture Tray click on the **Email** button and the **Select Email** dialogue box will open.
9. Click on the e-mail program you normally use. (In our case it's Eudora; yours might show Outlook Express, or some other program.)

TIP: AVOID E-MAILING VERY LARGE ATTACHEMENTS
Large files take longer to transmit and can create some problems for recipients. It's best to keep the total size of attachments at about 300kb for a dial-up connection, and around 600kb for broadband (DSL) connections.

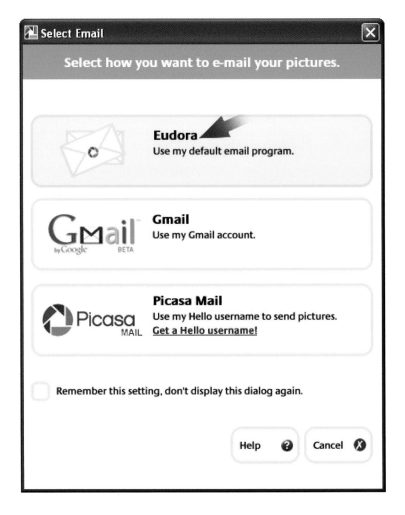

Your e-mail program will load and a blank e-mail will open with the selected files attached, ready for sending.

10. Type the recipient's name into the **To:** window of your e-mail.
11. Accept the text in the **Subject** line and in the body of the e-mail, or type your own text there.
12. Send your e-mail as usual.

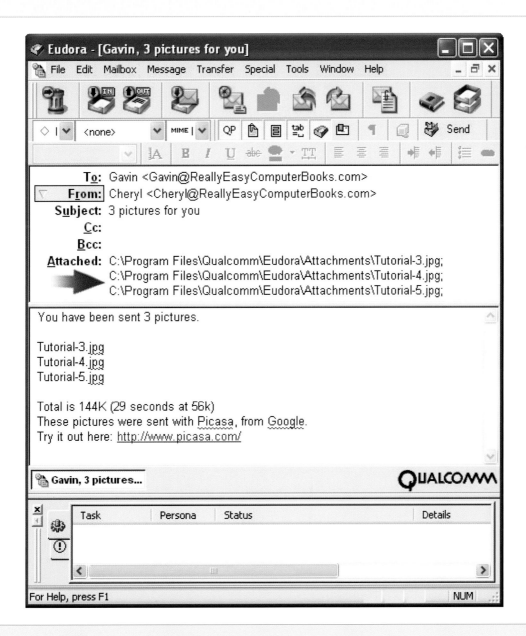

TIP: DON'T RESIZE ALREADY-RESIZED IMAGES
If you already have resized pictures that you wish to send by e-mail from Picasa®, then you could of course select them from the **Resized** folder. When you then select the image size in the **Options** dialogue box you would click on **Original** because the pictures have *already* been resized for e-mailing.

INSERTING PHOTOS INTO OTHER DOCUMENTS

If you're creating a newsletter, business report, greeting card and the like in a word processor such as Microsoft Word, or a PowerPoint slide show, you can add photos to your document and position them exactly where you want them.

In Microsoft Word

Inserting the image:

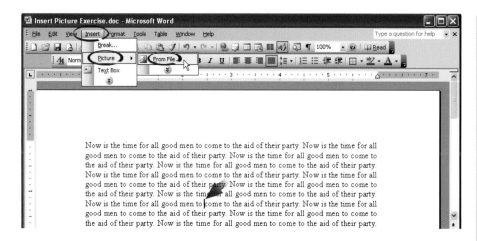

1. Open a new document in Word.
2. Type the text you plan to have with your photos.
3. Place your cursor inside the text where you want the first photo to appear.
4. On the Menu Bar, click **Insert**, then **Picture**, then **From File...**

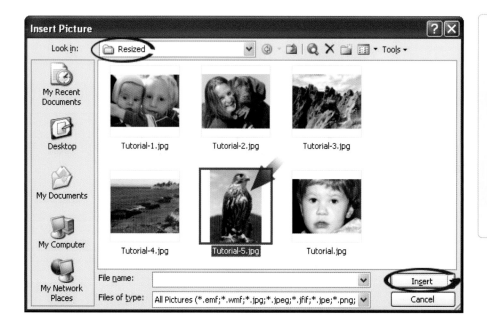

5. Browse to **My Pictures \Tutorial\Resized** and click on the photo you want to use to select it.
6. In the **Insert Picture** dialogue box that opens click on the **Insert** button.

The picture is then inserted into your document, but needs some text wrapping to improve the layout.

Positioning the image with the text:

7. Now is the time for all good men to come to the aid of their party. all good men to come to the aid of their party. Now is the time for all o the aid of their party. Now is the time for all good men to come to 7. Now is the time for all good men to come to the aid of their party.

Cut
Copy
Paste
Edit Picture
Show Picture Toolbar
Borders and Shading...
Caption...
Format Picture...
Hyperlink...

all good men to come to the aid is the time for all good men to come to the aid of their party. Now is d men to come to the aid of their party. Now is the time for all good

7. Right click on the picture that is now placed in your Word document, then click on **Show Picture Toolbar**.

8. On the **Picture Toolbar**, click on the **Text Wrapping icon** to show the text wrap options.

9. Click on **Square** and the text will wrap around your picture. (Try other text wrap options as well.)

In Line With Text
Square
Tight
Behind Text
In Front of Text
Top and Bottom
Through
Edit Wrap Points

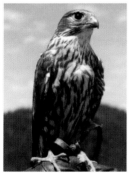

Now is the time for all good men to come to the aid of their party. Now is the time for all good men to come to the aid of their party. Now is the time for all good men to come to the aid of their party. Now is the time for all good men to come to the aid of their party. Now is the time for all good men to come to the aid of their party. Now is the time for all good men to come to the aid of their party. Now is the time for all good men to come to the aid of their party. Now is the time for all good men to come to the aid of their party. Now is the time for all good men to come to the aid of their party. Now is the time for all good men to come to the aid of their party. Now is the time for all good men to come to the aid of their party. Now is the time for all good men to come to the aid of their party. Now is the time for all good men to come to the aid of their party. Now is the time for all good men to come to the aid of their party. Now is the time for all good men to come to the aid of their party. Now is the time for all good men to come to the aid of their party. Now is the time for all good men to come to the aid of their party. Now is the time for all good men to come to the aid of their party. Now is the time for all good men to come to the aid of their party. Now is the time for all good men to come to the aid of their party. Now is the time for all good men to come to

TIP: RESIZE THE IMAGE TO FIT
You can safely make the picture smaller by clicking on the picture to select it in Word, then dragging the corners to reduce the size. Enlarging the picture can, however, result in a loss of picture quality.
Golden Rule: Size down, never up.
Experiment with different photos and different word wraps.

In PowerPoint

You can insert a picture into a PowerPoint slide to enhance your presentation.

1. Open PowerPoint to create or edit your slide show.
2. To insert a picture into a slide, follow the same procedure as for inserting a picture into a Word document.
3. To resize the picture once it's been inserted into the slide, click on its corner handles and drag them inwards or outwards until the picture is sized the way you want it.
4. To move the picture around, click on it and drag it to where you want it to be positioned.

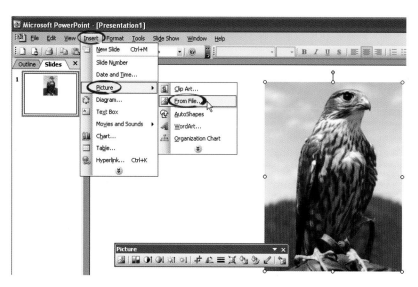

TIP: DOCUMENTS AND SLIDE SHOWS

To learn more about creating documents and slide shows in Microsoft Word and Microsoft PowerPoint, read our companion titles, *THE REALLY REALLY REALLY EASY COMPUTER BOOK 1* and *BOOK 2* (see p108).

SHARING YOUR PHOTOS ON THE WORLD WIDE WEB

You can publish your photos onto a Web page quite easily using one of the many free Web services that make this possible. Picasa® offers a service called *Hello*. You can check it out via the Picasa® Help menu. Another one is offered by Bravenet. The web addresses of both these services are given below.

http://www.hello.com

http://www.bravenet.com

There are also other services that offer online photo sharing on the Web. Some even allow you to order items featuring your own special photos on them, such as coffee mugs, T-shirts, caps, and the like, which make great gifts. Check out these sites as a start:

http://www.shutterfly.com

http://www.photobox.co.uk

http://www.kodakgallery.com

Protecting your copyright

Once your photographs are on a Web site anyone anywhere in the world can, of course, save them to their own computer and use them freely. They can even edit and misuse them. One way to try and prevent this invasion is to use a text-capable photo editor to add a watermark or ownership statement to each image.

If you're publishing photos to your own Web site, another way is to put a copyright notice on your site. Then, if you discover that someone is using your photos on another site without your permission, simply e-mail them and ask that the photo(s) be removed. Usually the unauthorized user will sheepishly comply with your request.

Getting started with photo taking 5

OVERVIEW

This chapter will help you navigate your way around your digital camera so that you have a basic understanding of its various components and functions, and be able to take some point-and-shoot digital photos without delay, with excellent results.

! **For this chapter, and for those that follow, you'll need to have the use of a digital camera. If you plan to buy your own for this purpose, make sure you first read through this part of the book and, in particular, Chapter 8 which offers useful tips on how to choose the right camera for your needs.**

Although the basic features of most digital cameras are essentially the same, each manufacturer and each model has its own particular design and way of doing things: displaying its menus, switching operating modes, and so on – much like one finds with the enormous variety of mobile (cell) phones available today. It is therefore very important that you carefully study the camera owner's manual for the camera you'll be using.

In this part of the book you will need to work *in conjunction with your camera's manual*, and also with your camera at hand. Where we include a little 📖 icon that looks like a book, this means it's essential that you stop and refer to the camera's manual on that particular point or topic, and that you do it there and then, not some time later. This will help to bring to life the information you're reading in this book and ensure that you gain a practical hands-on understanding of the knowledge as it applies to your particular camera.

INSERTING THE BATTERIES AND STORAGE CARD

Every camera needs a power source, usually in the form of several AA-size batteries, or something similar. Some cameras come with regular batteries that can be inserted into the camera immediately. Others are supplied with rechargeable batteries or battery packs that must first be charged according the instructions in the manual.

1. Charge the batteries if they are the rechargeable type.
2. 📖 Insert the batteries into the camera's battery compartment, making sure you have the positive and negative poles in the right direction per the manual. (Usually, little icons inside the battery compartment indicate the (+) and (-) poles.)
3. 📖 Be sure to read the camera manual's safety precautions regarding the batteries.
4. Fit the safety strap to the camera, and be sure to use it every time you carry the camera outside its protective case. (If you don't have a camera case, buy one to protect your investment.)
5. If you have a removable lens cap with a safety strap clip, fit the strap to the clip to avoid losing the expensive cap (see Tip on p65).

TIP: SECURE YOUR LENS CAP

Without a lens safety strap, lens caps are easily lost, often repeatedly. A replacement lens cap is much more expensive that a safety strap, so if you have a lens cap without a safety strap and clip, buy one as soon as possible. If necessary, attach a cord with glue; but *attach* one for sure.

6. 📖 Insert the **media storage card** to which your new pictures will be saved until they are downloaded to a computer or printer.
7. 📖 Turn the camera on at its power ON/OFF switch.
8. 📖 Set the Mode Dial to **Auto**.

SETTING THE MODE TO AUTO

If you're a new user of a digital camera, for your first shots we suggest you let the camera make all the settings for you – distance, brightness, and so on. It does this according to the subject you wish to photograph.

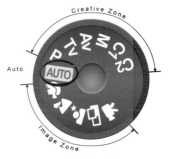

Mode Dial

To use AUTO mode you simply select it by turning the *Mode Dial* to select the AUTO icon, which is usually green, sometimes in the shape of a camera. As a minimum, AUTO mode normally determines the following key parameters and makes the optimum settings accordingly.

1.	Type of lighting	The camera determines the white balance according to the kind of lighting (natural light, indoor lighting, fluorescent light, etc.), to be able to reproduce colours more accurately. This will be explained in more detail in the next chapter.
2.	ISO sensitivity level	This is the digital equivalent of the ISO sensitivity rating used with camera film. A higher ISO rating (anything above 400 ISO) increases the graininess of the photo; the lowest possible ISO rating is best. AUTO determines this setting for you, usually selecting a rating between 100 and 200.
3.	Aperture (f-stop)	This means the size of the hole or aperture that lets the light into the camera through the lens. (Big hole = more light, less of the image in focus; small hole = less light, more of the image in focus.)
4.	Shutter speed	This refers to how fast the shutter opens and closes to let in the light. (Longer time open = more blur; shorter time open = sharper image.)
5.	Whether flash is needed	If there's not enough lighting on the subject (which will result in an unclear image), AUTO will set the flash to fire when you take the picture.

As you become more adventurous you can start using settings other than AUTO so that you are able to adjust these settings yourself in order to create the effects you require in your pictures. But for now, set the camera to AUTO mode and let the camera do everything, except aiming at the subject and pressing the shutter release button to take the shot.

COMPOSING YOUR PICTURE

Most digital cameras offer two ways of viewing the scene in order to view the content of your intended picture: an optical viewfinder and an LCD monitor (see illustration below). Each has its advantages and disadvantages.

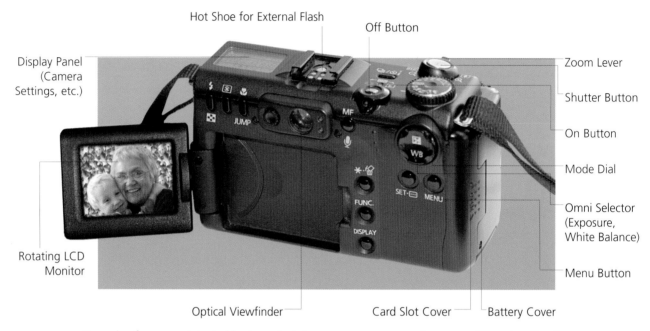

Example of a camera's typical basic controls (your own camera may have very different options)

The optical viewfinder

The optical viewfinder is what all film cameras use and should be part of every digital camera as well. On single lens reflex (SLR) cameras what you view through the optical viewfinder is being viewed through the main lens, and therefore is also what will appear on the photograph that is taken.

On digital cameras, other than SLR's, the optical viewfinder is altogether separate from the camera's lens, and is used solely for the purpose of framing the picture you intend to shoot. This creates two problems for the photographer.

Problem 1 – Close-up photos can lose some side/top content:
Because of the physical separation between the viewfinder lens and the camera lens, the image you see in the viewfinder does not match up exactly with the image as seen by the camera's lens. This is called the parallax phenomenon and is particularly noticeable when taking close-up shots, where the subject appears in the centre of the viewfinder but will be captured off-centre in the actual photograph. The result of this phenomenon is that parts of what you see in the viewfinder will not appear in the photo you've taken because they were not actually in the view of the camera's main lens itself.

So, when using the viewfinder for composing your picture, you'll need to take this into account and allow some extra margin to make sure that your camera captures everything you want to be in the picture. Usually there are parallax correction lines in the viewfinder to help you make this adjustment for the parallax error. 📖

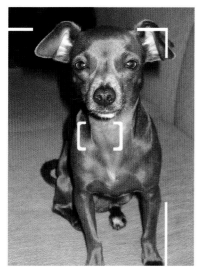

The white parallax correction lines indicate the borders within which the subject should be framed for the close-up photograph.

Subject centred in the viewfinder, but not within white parallax frame, so in the photo the dog is off-centre and her ears are partially cut off.

After framing the dog within the parallax correction lines for the close-up, the subject is centred and her ears are not cut off.

Problem 2 – The camera captures more than you see in the viewfinder:
The optical viewfinder usually sees about 80 per cent of what the camera lens sees, which means that the photo taken by the camera will have more content than you intended. So the beautiful scene you thought you were capturing ends up in the photo with unwanted, often unattractive, content around the borders (top, bottom and sides). One advantage of using the optical viewfinder, however, is that it can be used in any lighting conditions, whereas this is not the case with the LCD monitor.

The LCD monitor

Unlike the optical viewfinder, the LCD monitor displays more closely what the lens sees, so it is usually better to compose your picture using the LCD monitor. However, the LCD monitor does use more battery power, and in bright sunlight it can be very difficult, if not impossible, to see the image. (Some manufacturers have already addressed this problem.)

The general recommendation therefore is to frame your picture with the LCD monitor wherever possible, and to use the optical viewfinder in bright sunlight, remembering to take into account the parallax phenomenon for close-up shots, and doing your best not to include unwanted elements in the scene.

TAKING AIM TO SHOOT

1. Firmly grasp the camera in your right hand and place your index finger on the **shutter release button**, usually at the top of the camera. 📖
2. Look through the viewfinder (if your camera has one) or use your LCD monitor (a small screen) to compose your picture.

When you are viewing the subject through the viewfinder or on the LCD monitor you should see a little rectangle or circle in the centre of the viewer. This *AF (Auto Focus) frame* is there to assist you with focussing on the main subject.

3. Move the camera slowly until the main subject is centred in the auto focus (AF) frame.
4. Hold the camera steady and press the shutter release button **half way** down (you should feel it reach the half-way point) and **wait for about two seconds** while the camera adjusts the three key auto-settings explained below. (You can also *hear* it focussing; when the mechanism becomes quiet, it is ready to take the shot.)

TIP: HOW TO HOLD THE CAMERA STEADY

Moving the camera while you are shooting can result in blurred photos. Use your left hand to support the camera by holding the left side of the camera. If it has a heavy lens, hold the bottom of the lens. Keep both elbows pressed lightly against your body, and place one foot in front of the other to stabilize your whole body.

The camera's automatic settings

- Auto Focus: Focuses the lens so that the subject in the centre of the picture frame will be crisp and clear.

- Auto Shutter Speed: Sets the shutter speed which determines how long the shutter will stay open to expose the light-sensitive chip inside the camera to the light coming in from the subject being photographed.

- Auto Aperture: Sets the f-stop, or *size* of the aperture (opening) through which the light enters the camera. This determines therefore *how much* light reaches the light-sensitive chip in the given period of the exposure.

These three settings all work together to determine the clarity, brightness, colour and focus of the various elements composing the final picture's content. The camera needs a second or two to make these settings, which is why it is necessary to hold the button half-way down for about two seconds.

6. Steadily, without moving the camera, press the shutter release button completely down to release the shutter and take the picture. (📖 You'll hear a sound to tell you this has happened.)
7. Immediately review your picture on the LCD monitor to see if it's acceptable to you. If not, take another picture. 📖

TIP: QUICK PREVIEW OF THE SHOT JUST TAKEN
On many cameras, if you've set the preview feature to ON, immediately you've taken a photo the picture will be displayed on the LCD screen for a very brief time (about two seconds or so), so you'll need to check quickly to see the image. On some models, if you keep the shutter release button pressed all the way down after you've taken the shot, the image will continue to be displayed on the LCD screen until the button is released. This is useful, for example, if you want to move into the shade to see the image more clearly on the LCD screen. Some cameras also allow you to change the immediate display duration, for example from two seconds to 10 seconds. Consult your camera manual on this. 📖

SAVING SPACE ON YOUR STORAGE CARD

If you have a low-capacity storage card (e.g. 8, 16, 32 or 64 megs), and you're not going to be able to download the images as soon as the card is full, set your LCD monitor to *Replay* mode 📖 so that you can check all your photos on the LCD screen and delete any unwanted images and duplicates. This will free up space on your memory card for more photos to be taken before the card is full.

1. Turn the mode dial to set the display to **Preview** or **Replay** mode. (This might be an icon on the Mode Dial or a button on the camera.) 📖
2. 📖 Use the **Forward** and **Back** scroll buttons to move from picture to picture and delete any unwanted pictures.
3. 📖 Read the camera's manual for any other display options available on your camera model, such as viewing multi-images on the LCD screen, zoom display, etc., and how to select and delete an image from the camera.

Using other settings and modes

SETTING THE DATE AND TIME

Sometimes it's useful to select the option to display the date and time on certain photos. Even if you don't use this option, this information is stored in the data file of each photograph for future reference. So it's a good idea to have the correct date and time available in your camera.

Set the correct date and time on the camera now so that this information is recorded with each shot you take and will be available when you need it. 📖

SETTING THE LANGUAGE

Usually camera menus are set to the language of the country in which the camera is sold. It's best to make sure at the outset that your camera is set to the language of your choice.

Set your camera to display menu information in the language you need. 📖

SAVING BATTERY POWER

Conserving battery power is a critical issue with digital cameras. Most cameras automatically turn off the power supply after they've been idle for a while, if the power saving option has been set to ON. You can usually set the power-down timing yourself. If your camera powers down and you want to use it again, simply turn it back on again per the camera manual's instructions. Usually this requires touching the shutter button, or the ON/OFF button, or one of the other buttons, depending on which mode the camera is set on. 📖

Study the information about power saving in your camera's manual. 📖

REDUCING RED-EYE

Red-eye was explained in Part 1 of this book. Some cameras have the option to reduce (not eliminate) red-eye by doing a series of mini-flash bursts or projecting a steady light towards the subject before the picture is taken. This aims at causing the subject's pupils to contract and thereby show a smaller amount of red than would be seen with a full, expanded pupil.

If your camera has the red-eye reduction option, turn it on. 📖

SETTING THE IMAGE QUALITY

Image resolution

Digital images are made up of very small squares of colour called pixels. The term resolution refers to how many pixels an image has per linear inch (Pixels Per Inch, or PPI). The higher the PPI, the clearer your image will be, because more pixels or coloured building blocks are used to build the image.

Image with a good resolution, showing how the eye perceives the pixels merged into one visual impression of the various colours

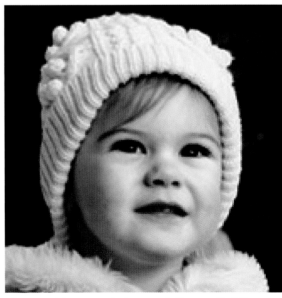

Image with extremely low resolution, so that the eye actually sees the individual pixels, making for a very poor quality image

The size at which a picture can be displayed or printed in good quality depends on the image's resolution. The lower the resolution (or number of pixels making up the image), the smaller the image can be when displayed or printed without its losing much quality. Otherwise, if you try to print a large image from a picture with a low resolution, the eye will see the pixels and the image's poor quality will be obvious. High-resolution images can be safely printed out in various sizes; you cannot, however, make a low-resolution image bigger or better.

Higher-resolution images do take up more memory on the media storage card, and on the computer, because the files are larger. So, when deciding at what resolution to set the camera for the particular photo you'll be taking, you'll also need to take into account what the image will be used for, and also make sure you have enough remaining capacity available on the memory card. The rule of thumb is to favour the highest possible resolution for the circumstances. The settings are often specified on the camera's menu options as shown in the first column of the table below:

Setting	Resolution	Uses
Large	2272 x 1704 pixels	For printing large prints
Medium 1	1600 x 1200 pixels	For printing large prints
Medium 2	1024 x 768 pixels	For fitting more images on the memory card; e-mail attachments
Small	640 x 480 pixels	For Web pages or printing on small labels

Access your camera's menu system and set the **resolution** to a **High** setting for now. (You can change it to a lower setting later, as necessary.)

Image compression

Digital cameras compress images, using the JPEG file format, to make them smaller and thereby save space on the memory card. There are usually three settings to choose from:

Superfine	– Higher quality images
Fine	– Normal quality images
Normal	– Reasonable quality images with more images storable on the memory card

UNDERSTANDING THE BASIC SHOOTING MODES

There are three broad groups of *modes* on digital cameras:

Auto mode	Where the *camera* makes all the settings for you, as already explained.
Scene modes	Where *you* specify the type of scene – very close, distant, night scene, etc. – and the camera adjusts all the other settings automatically. You could call these *selective automatic* modes. (For more detail, see the SCENE MODES heading on p72.)
Creative modes	This feature, included in some models (depending on price range) is where you set most of the shooting parameters yourself – aperture, shutter speed, special effects, and so on. This is explained in more detail in the next chapter.

! **Some cameras use the Mode Dial to show most of the mode options. Other makes or models will have some of the options on the Mode Dial while others are accessed via menus on the LCD monitor and then activated by buttons on the back of the camera. As we are using a particular camera make and model for this part of the book, you may need to adapt the information to the model of camera you are using. Manufacturers use different terminology to describe the same thing. We've used the more common terms and supplemented these with synonyms where possible.**

HANDS-ON MODE EXPERIMENTING EXERCISE

For *each* of the following scene modes we suggest you do the following:
1. Read and understand the explanation given for the mode, using the pictures alongside to clarify what is meant.
2. Then immediately read about that mode in your camera's manual to know where to access the menu for changing the setting to that mode. 📖
3. Set your camera to that mode.
4. Apply your knowledge by taking a photo in that particular mode, and reviewing it on the LCD monitor.
5. When done, move on to the next mode and repeat steps 1 to 4 until you have a good grasp of each of the scene modes explained in this chapter.

USING THE SCENE MODES

The following scene modes are available on most digital cameras. Your camera may have more modes, or a few less, depending on whether it is an entry-level model at a lower price or one at the higher end of the price range. Experiment with the modes that are available on the camera you're using. 📖

Common scene modes

 Macro/Close-up – subject is 16–76cm (6–30in) from the lens

This mode is for taking pictures of subjects extremely close up, between about 16 and 76cm (6–30in) depending on where the lens is set (wide angle to telephoto). It is used to take close-ups of a subject such as a flower, leaf or insect. The camera adjusts the AF (auto focus) sensors for extremely close focussing.

Because of the closeness of the subject, any slight movement of the camera can result in a blurred picture. If you intend doing a lot of macro shots it's a good idea to buy yourself a sturdy tripod to prevent camera shake.

 Snapshot/Portrait – subject is 1.5–2.5m (5–8ft) from the lens

This mode is used to take pictures where the subject is fairly close – between 1.5 and 2.5 metres (5–8ft) from the lens – and is used for shooting close-ups of subjects such as flowers, people's faces and objects of interest. The camera uses a wider aperture which has the effect of softening (blurring) the background and foreground somewhat to make the main subject the prime focus of the picture.

 ### Landscape/Infinity – the subject is more distant from the lens

Landscape/Infinity is used to shoot scenes such as landscapes, mountains and any subject in the distance. It is also used for compositions that combine both near and distant objects. In this mode the camera uses a small, or narrow, aperture so that all of the content in the picture is seen to be in focus without blurring. This is referred to as having a wide depth of field (of focus).

 ### Night Portrait/Slow Synchro – captures background detail in dimly lit scenes

Often referred to as *nighttime* mode, the *slow-synchro flash* setting forces the camera to use a slow shutter speed in combination with flash bursts. This enables the capture of more background detail in dimly lit scenes such as portrait shots at twilight, or indoor shooting where it is important to capture the mood of a setting as well as to have the main subject properly exposed by the flash. The camera must be held very steady when using slow-synchro flash to prevent the background from blurring. It is best to use a tripod for this mode.

 ### Flash Auto / On – for brightening the subject

The flash can be set to fire under different situations:

AUTO: It fires automatically if needed, based on the light levels.

ON: It fires irrespective of the light level. This is useful when the overall light level is bright enough for the shot, but the main subject itself is in shade or is not well lit and needs some extra lighting to give a good picture. It is also used as *fill flash* when the backlighting is very bright.

 Flash Off – even in low lighting

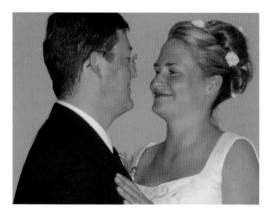

This mode (sometimes accessible only in Program AE mode) disables the flash so that it won't go off at all, even when low lighting would normally trigger the flash. It can be used when flash photography is not allowed or is undesirable (e.g. in places of worship, for discreet photography, and so on). When the flash is turned off in basic modes, the camera will compensate and adjust the aperture, shutter speed and ISO to suit the dark conditions. Try to avoid camera shake as much as possible.

 Self-timer/Self-portrait – automatic, operator-free shooting

When you want to be in the picture yourself, you would set the camera up on a tripod or table, set the self-timer to allow enough time for you to get in front of the lens, and wait for the camera to shoot the picture automatically when the timer reaches zero. This feature can be a lot cheaper than asking a stranger to take the photo for you before he runs off with your camera.

Telephoto/Optical Zoom – *optically* bringing the subject 'closer'

Many cameras have a telephoto option (usually activated by a button) which allows you to zoom in on a subject to bring the image much closer. This is useful for wildlife shots and any other photos where you want a closer view of the subject than you can physically obtain.

 Normal wide-angle view

 Telephoto view

Digital zoom – *digitally* magnifying the subject to make it appear even closer

By manipulating the view *digitally* you can seemingly bring the subject in even closer. Note, however, that the more an image is digitally zoomed the more grainy and unclear the picture will be. So digital zoom is generally not recommended for good quality photos. What digital zoom is really doing is *cropping* the picture seen in *optical* zoom, to 'magnify' it. It doesn't change the focal length at all. There is no real advantage to using this feature. It would be more effective to use optical zoom only, and then crop your picture in your photo editing program. If your camera has a digital zoom option, we suggest you experiment with it and then turn the option off.

Stitching/Panorama assist – creating a wide panorama picture

If your camera and software support *Stitch* mode, you can take a series of single shots of a scene, from left to right, with each view overlapping the previous one by 40–50 per cent. Then, using your software, you can 'stitch' them together to form one seamless, wide panoramic scene. The illustration below shows how each photo overlaps the previous one, with the duplicated content hidden behind the preceding photo. The software uses these overlapped areas to line up features in both adjacent pictures that will enable it to match each shot accurately. It then 'stitches' the images together digitally to end up with a continuous panoramic image. When you use this feature, make sure each overlapping scene contains a distinctive feature that the software can identify as a means for obtaining alignment (i.e. not just one long expanse of 'sameness', like water, sea sand, etc.).

Four separate photos with overlapping scene content

Stitched together by the software to create a wide, seamless panorama

Continuous – repeater shots

In this mode you can set the camera to shoot individual shots of a scene continuously, at the speed determined by the camera, based on whether the flash is needed and the amount of available memory. This can be useful for sporting events and other action scenes where you're not quite sure when something dramatic will happen that needs to be captured. It gives you a selection of sequential shots from which you can later make your final selections. We recommend that for *Continuous* Mode you turn the flash off, as it slows down the number of shots per-second and therefore defeats the purpose of using continuous mode.

Movie/Video – for creating short video clips with sound

Many digital cameras support the shooting of a short video clip, usually with sound captured via a built-in microphone. Video clips are normally stopped automatically when the time is up or the memory card is full. Bear in mind that they do consume a lot of memory space on your card. Video-clips are usually used only for special scenes that you might want to e-mail as an attachment. If you want to take longer and better-quality video scenes then it's best to invest in a video camera designed specifically for creating moving pictures.

Additional automatic modes available on some models

Party/Indoor
– indoor background and detail

Sunset
– dawn and sunset

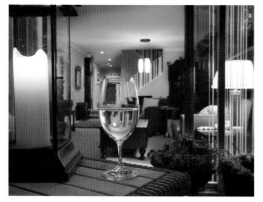

This is used to capture background detail or the effects of candlelight or other indoor background lighting.

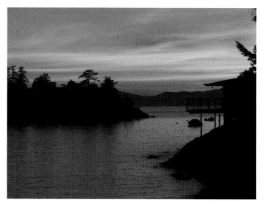

This mode helps to capture the deep red and golden hues seen at sunrise and sunset.

 ## Dusk/dawn
– just before sunrise and after sunset

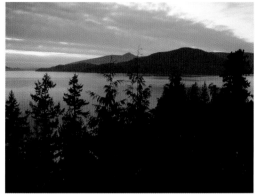

This mode helps to preserve the colours associated with the weak natural light seen just before sunrise and just after sunset.

 ## Night landscape
– city lights

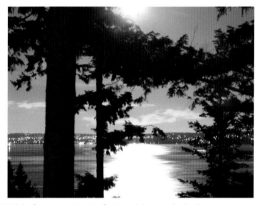

With focus set at Infinity, this mode helps to create excellent landscape scenes at night, such as city lights some way in the distance.

 ## Beach/Snow
– bright reflected natural light

The bright reflections of snow or beach confuse the camera; it thinks it needs to reduce the exposure, and this makes the scene look dull. This mode is used to override the camera's auto setting and increase the exposure to create the proper effect.

 ## Museum/Discreet
– indoor without flash

In this mode the flash does not fire so it is useful for taking pictures in museums, art galleries, or anywhere that indoor flash is not permitted or desirable.

 ### Underwater
– for underwater scenes

This mode creates vivid pictures of aquatic life
as seen through or below the water's surface

 ### Fireworks
– for capturing sudden
light flashes at night

Fireworks Mode uses a slow shutter speed to capture the
ever-expanding bursts of light from fireworks or sparks.
The camera focuses at infinity.

Copy/Document
– close-ups of white documents

This mode is used for taking shots of documents or charts on
white paper or board, such as reports, business cards, typed
documents and the like.

 ### Backlight/Fill flash
– filling in shadows

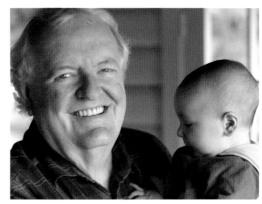

Use Backlight Mode when light is coming from behind a
subject, which can throw the subject's features into shadow.
The flash fires automatically to 'fill in'
or illuminate the shadows.

USING 'FOCUS LOCK' TO GET THE FOCUS YOU WANT

If you look at the centre of the LCD monitor when the camera is in shooting mode, you'll see a small focusing ring, square or several squares in the display. This indicates that whatever is in the centre of your picture composition will be what the camera will use to set the focus in auto-focus mode. Sometimes, this is not appropriate as a method of obtaining a clear focus on the main subject of your picture, for example:

- where the subject and the surroundings are not clearly contrasted;
- where there is an extremely bright or differentiated object at the centre of the composition;
- when subjects are moving fast;
- when subjects are photographed through glass;
- when you want the subject to appear off-centre in the picture, not dead-centre.

To allow for easy manipulation of this auto-focus feature, most digital cameras have a feature called *focus lock* which is usually activated by pressing and holding the shutter release button half-way down. It is used when auto-focussing is not appropriate for the kind of picture you want to take.

As an example, here's what to do if you want your main subject to be off-centre in the picture, and yet remain in sharp focus:

1. Compose your picture in the viewfinder or LCD monitor, with the subject positioned off-centre, showing the picture as you ultimately want it to be.
2. Then move the camera so that your main subject is temporarily *centred* in the viewfinder.
3. Press and hold the shutter release button half-way down to obtain focus on the subject and to lock in that focus.
4. Now, still holding down the button to half way, move the camera back to position your subject off-centre again; and finally press the shutter release the rest of the way down to take the shot. (Usually there'll be some sort of light – often a green one – located next to the viewfinder that glows when you have sharp focus.)

Where you'd like the subject to be positioned

With the subject positioned off-centre while composing the picture, the centre focussing ring would be aimed at the background because that is the centre of the scene. The background would therefore remain in focus when the shot is taken. The subject, who is closer than the background, would be blurred and out of focus.

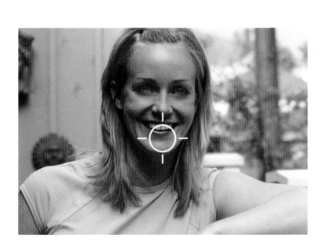

Positioning the subject temporarily in the centre to lock the focus

Positioning the focusing ring over the main subject, then pressing and holding the shutter release button half-way down sets and locks the focus. With the button depressed half-way, you can recompose the picture with the subject off-centre. The focus has been 'locked', so the subject will remain in focus. The background will be out of focus.

The picture how you wanted it

Although the subject is off-centre, because focus was locked on the subject and not the background, she still remains in focus and clear, even though the focussing ring is centred on the background while the shot is taken.

STUDY YOUR CAMERA'S FUNCTIONS CAREFULLY

Now that you've had an introduction to digital cameras, this is a good time to read through your camera's manual carefully and study the functions and modes already covered in this chapter. Refer back to this chapter where you need to refresh your memory on what the purpose is of a particular function or mode on your camera.

Digital cameras have a lot of features that we've found many people don't use simply because they haven't made time to read their manuals thoroughly, or because the manual is not written in a user-friendly way for a beginner. So, work with the camera, its manual and this book, together, in order to familiarize yourself with the options available on your particular model.

Learn how to access each one of the modes and settings via the mode dial and the camera's menu system. Do it often as there's a lot to remember and practice will make you more familiar with your camera so that you can get the most out of it in terms of quality photos.

Creative photo taking 6

OVERVIEW

In Chapter 3 you learnt how to enhance and modify digital photos that had already been taken by the camera. In this chapter you'll learn how to create most of the effects you want, right at the photo's inception. It's always better to edit a good photo than to try to fix a bad one. And it's also fun to try out the different effects possible by making adjustments between the focus, lighting and speed settings before you shoot the picture.

Understanding light

The word photography is derived from the Greek word *photos*, meaning *light*. The word *graph* is the Greek word for "writing" or "drawing". *Photography* is thus all about writing, or drawing with light. The heart of photography is indeed *light*. So to be creative in taking photographs means being creative in the way one uses external lighting as well as in the way one decides to set the camera to deal with the incoming light when it reaches the light-sensitive sensor inside the camera to create the digital image.

PUTTING NATURE'S LIGHTING TO GOOD USE

There are essentially three periods in a day, and each of these periods has its own unique light characteristics. You can photograph exactly the same scene at different times of the day and end up with completely different results simply because the natural lighting has changed.

Sunrise

As the sun comes over the horizon, with its light being filtered through a greater segment of the atmosphere, purple hues, warm golds and reds add a special quality to our experience of the light and how it is captured in a photograph.

As another day is about to begin, the warm, low lighting creates soft golds and muted shadows.

There are times when the liquid heat and hard shadowing can create a beautiful special effect as the sun's rays bounce and twinkle off the water as seen in the photo above.

Noon

When the sun is at its zenith the bright, neutral light is quite harsh for most photography. However, this can be useful where shadow patterns and creativity are important, and also for landscape scenes. It's best not to take important photos of people in the intense noon-day sun.

Sunset

The period from just before until just after sunset is also a time when the sun's rays are filtered through more of our atmosphere, producing the warmest and most intense natural light of the day. The deep reds, yellows and golds make for vibrant colours when photographed. This is usually an excellent time for taking photos.

Filtered light from a setting sun, just before it disappears over the horizon, casts warm golden light on what might otherwise have been a dull brown subject.

Look up to the skies on a cloudy day and you might be surprised to find that the best photograph is straight above you.

Cloud

There's another important aspect to natural light that will also affect what a photo will look like, and that is cloud. Although many people believe that bright sunlight is the best lighting for taking good photos, this is not so. Often human subjects have to squint and half-close their eyes to cope with the sun's bright rays and reflections. A cloudy day is often better for photography than bright sunlight because the diffused light gives a softer, more even illumination, with less harsh shadows. Some cloud formation can create quite a dramatic effect, at any time of the day.

COMPENSATING FOR LIGHT 'TEMPERATURE'

Digital cameras use what is known as *white balance* (WB) to modify the colour temperature, a feature that users of digital cameras often overlook. It's important to tell your camera what kind of temperature is in the scene you want to shoot so that it can set the *white balance* accordingly.

To make these settings the digital camera uses the temperature ratings according to the Kelvin Scale (K) where each colour of light corresponds with a *colour temperature*. Normally we know a higher temperature as being warmer and a lower temperature as being colder. However, with *colour* temperature it is the opposite way around:

Lower temperature = warmer colours
Higher temperature = cooler colours

Cameras don't automatically detect different colour temperatures in the light (though they are able to estimate reasonably accurately on the Auto White Balance setting), so it might be necessary for the user to set the white balance according to the type of lighting prevailing in the scene. You do this by adjusting the WB settings available on the camera, for example: daylight, cloud, indoor light bulbs (tungsten), fluorescent, and so on. If the camera is set to *AWB – Automatic White Balance –* it will do a half-decent job of adjusting the colour temperature. However, to achieve a more accurate adjustment it's best to use the camera's separate white balance settings as explained on the next page.

ADJUSTING WHITE BALANCE FOR ARTIFICIAL LIGHT

There are essentially two kinds of artificial lighting, each with its own characteristics that need to be taken into account and for which camera adjustments are recommended. (Decent cameras should be able to cope with both of these light conditions, provided the Auto White Balance setting is selected.)

Incandescent/Tungsten light

This is the light typically used in homes – the ordinary electric light bulb with a tungsten filament. Its light is warmer in appearance than daylight or flash. When the camera's white balance is set to *Daylight*, or if the camera is in *Auto* mode, tungsten lighting produces a yellow/orange cast in photos produced with a digital camera. So, to adjust for this, you'll need to set the camera's white balance to *Tungsten*. 📖

Yellow/orange glow of incandescent lighting Using correct white balance for indoors

Fluorescent

This is the light produced by fluorescent tubes as typically seen in offices and public places. If the camera's white balance is set to *Daylight*, or if the camera is in *Auto* mode, fluorescent lighting produces a green cast in digital photos. Under this lighting you should set the camera's white balance to *Fluorescent*. (Some cameras have two optional fluorescent settings.) 📖

Green cast produced in fluorescent lighting situations Using correct white balance for fluorescent lighting

TIP: MANUALLY ADJUSTING WHITE BALANCE

In *Auto* mode the white balance is set automatically by the camera: *AWB – Automatic White Balance*. Where other modes are available (such as *Program*, *Av*, *Tv* or *Manual* modes) these give you access to additional settings options. This makes it possible to set the white balance manually to suit the respective light source, such as for a cloudy daylight scene or any custom setting of your choice. 📖
To set the white balance to a perfect setting for the particular scene, hold up a white piece of paper or cloth, or a photo-quality grey card (available from camera supply stores), in front of the lens and adjust the white balance accordingly, per the manual's instructions. 📖

USING THE FLASH IN POOR LIGHTING CONDITIONS

The flash is used when additional lighting is necessary to illuminate the subject. On most compact cameras with a built-in flash, although the flash light extends to about 3–4.5m (10–15ft) the effect is usually useful only up to about 2m (6ft). Beyond that distance the light is less effective. The flash is particularly good for close subjects shot in low light or in the dark.

When the flash is used the shutter speed is automatically faster to compensate for the extra light the flash provides. This reduces the amount of natural light entering the lens. When the flash is used in a large room or in evening scenes where there is at least some natural light, this faster shutter speed can result in a dark image. A useful alternative would be to turn off the flash in favour of the natural light and use a slower shutter speed. This would allow more of the natural light to enter the camera and would result in a brighter overall image than with the flash.

TIP: AVOID BLURRING WITH SLOW SHUTTER SPEEDS

A slow shutter speed can result in blurring if the subject moves or the camera is not held steady.
If possible, ask any human subjects to remain still until you tell them the shot has been taken.
And keep the camera steady, or use a tripod to avoid camera shake.

Softening the harsh effect of the flash

The camera's flash simulates the white colour of the natural midday light and can sometimes provide a very harsh light when the subject is too close to the lens. There are times when disabling the flash produces a more desirable effect, as depicted in the two photos of the little girl.

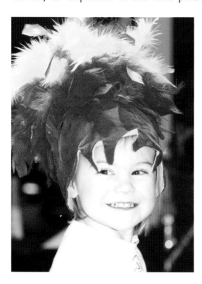

Camera flash blows out the photo, producing a washed-out image with no detail.

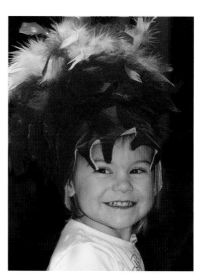

By disabling the flash and selecting a scene mode for indoors, the camera will automatically make the appropriate aperture and shutter settings, producing a much more natural shot with more detail.

Using 'fill flash' to fix front shadows

On overcast days, or where the subject is in the shade or the sun is behind the subject, use your flash to add more light. Because of the brightness of the sun, even when it is cloudy, the effect of the flash in daylight is not as harsh as in the dark of night. So during the day the flash plays a useful role in lightening an otherwise dark photo with what is termed *fill light*.

Taken without fill flash

Taken with fill flash

When the light is coming from different directions

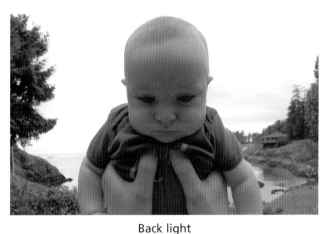

Incorrect Correct

Back light
(sun behind the subject)
Causes a dark silhouette with not much clarity in the subject itself. Use fill flash to brighten the subject.

Front light
(flash or direct sunlight)
When you're standing too close to the subject, direct sunlight, and especially flash, may result in a flat, washed-out, one-dimensional effect with not much texture detail. One solution, with flash, is to move away from the subject a little to reduce the flash effect. If direct sunlight is the problem, move the subject into light shade.

Top light
(high sunlight)
Causes harsh shadows under certain features, like a
tree, veranda, and a person's eyes, nose and chin.
Use fill flash to eliminate the shadows.

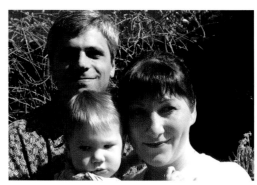

Side light
(sunlight)
Causes harsh shadows on one side.
Use fill flash to eliminate the shadows.

TIP: USING A FLASH DIFFUSER
To decrease the brightness of the flash's output
and create subtle fill-flash effects, consider
investing in a flash diffuser that is made
specifically for auxiliary (clip-on) flash units for
specific camera/flash types. The diffuser fits over
the end of the flash unit and softens the
harshness of the light emitted by the flash.
On some camera models there is an option to dial
back the power of the flash. Check your camera
manual for **Flash exposure control**. 📖
For cameras with built-in flash units only, you can
attach a small piece of tissue over the flash, but
take care not to let the tissue hang over the
camera lens.

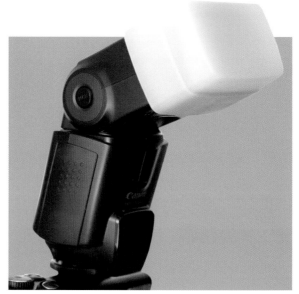

Flash diffuser

When to and when not to use the flash

- Up to 2.5m (6–8ft) from the subject
- As fill flash when the subject is in the shade or
 backlight causes the subject to appear too dark.

- Further than 2.5m (8ft) from the subject
- In large rooms with poor light (rather use a slower
 shutter speed, but hold the camera very steady)
- Distant evening scenes.

Understanding exposure

Exposure refers to exposing the light-sensitive sensor to light. There are essentially two key aspects to exposure:

- The *size* of the hole through which light enters the lens – the *aperture*, and
- The *speed* at which the shutter opens and shuts to let the light in – the *shutter speed*.

These two elements – aperture and shutter speed – work hand-in-hand to give the right amount of light at the right speed to produce a good photo of the kind you desire. Too much light will result in an over-exposed, washed out picture. Too little light will give you a dark image. Let's look at these two interdependent aspects of exposure more closely.

UNDERSTANDING THE APERTURE ASPECT OF EXPOSURE

The mechanism through which the light enters the camera is called the *aperture* – it can be widened or narrowed. The size of the aperture, stated as a number, is referred to as the *f-stop*. Just to confuse us all, the smaller the f-stop number, the wider the aperture, letting in more light; and the higher the f-stop number, the narrower the aperture, letting in less light.

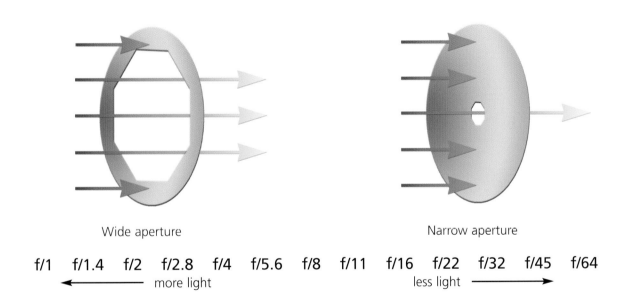

Wide aperture Narrow aperture

f/1 f/1.4 f/2 f/2.8 f/4 f/5.6 f/8 f/11 f/16 f/22 f/32 f/45 f/64

← more light less light →

Changing the depth of field (blurred or sharp background and/or foreground)
Besides affecting how much light enters the camera, the size of the aperture also has an effect on the depth of the field of focus. If you have a short (or narrow) depth of field, then the subject will be in focus but the foreground and background will be blurred. This can be very useful when you want the main focus of attention to be on the nearby subject, with the background simply offering a diffused blur of colour with no distracting definition. A narrow depth of field works best when the subject is fairly close. To achieve this, you would set the aperture to a lower f-stop (a larger aperture).

Wide aperture – shorter depth of field:

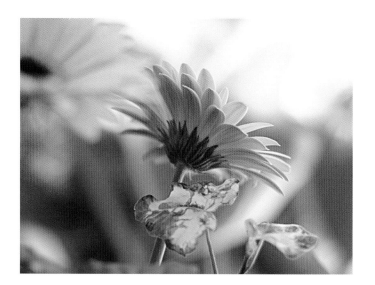

f-stop = f/2.8
More light striking the image sensor
Results:
1. Lighter image if the shutter speed is not set faster
2. Shorter depth of field of focus – blurred background and foreground

On the other hand, if you're shooting a landscape scene, such as mountains, forests, the ocean, or people not close to the camera, you would want a greater depth of field so that everything is sharply in focus. In this case, you would not reduce the f-stop to create a larger aperture, but would stay with the camera's standard aperture for *Landscape/Infinity* mode.

Narrow aperture – greater depth of field:

f-stop = f/11
Less light striking the image sensor
Results:
1. Darker image if the shutter speed is not set slower
2. Greater depth of field of focus – everything is in focus

It is for these reasons that the camera offers scene modes such as *Macro* (extreme close-up), *Portrait* and *Landscape/Infinity* so that the camera can give you the appropriate depth of field for the distance of the subject being photographed.

UNDERSTANDING THE SHUTTER SPEED ASPECT OF EXPOSURE

Together with aperture, shutter speed determines how much light enters the camera – the brightness or darkness of the image. But besides brightness, shutter speed also affects how clearly the camera captures movement. A fast shutter speed will capture a moving subject without blur.

With a slow shutter speed, however, the aperture remains open for longer. This means that the light sensor is receiving light reflecting from the subject for a longer period of time. So if the subject is moving (walking, running, canoeing, waving, etc.) then the light sensor will capture this movement as a blur. When the shutter speed is fast, then there is not enough time for the sensor to record the movement, so the image will be crisp and sharp and literally freezes the action.

How shutter speed is measured

Shutter speed is measured in seconds and fractions of a second. A speed of 1/30 means that it takes the shutter one thirtieth of a second to open and close. That's pretty fast. Yet a shutter can operate as fast as 1/8000th of a second on some cameras.

Seconds

1/8000, 1/4000, 1/2000, 1/1000, 1/500, 1/250, 1/125, 1/60, 1/30, 1/15, 1/8, 1/4, 1/2, 1, 2

Shutter speeds as measured in seconds and fractions of a second

Where the subject is a moving subject, too slow a shutter speed can result in a blurred image.

Changing the clearness or blurredness of the subject

Sometimes you may deliberately want to emphasize the effect of motion by slowing down the shutter speed to blur the moving subject. For example, you might want to soften a waterfall to give it that misty, cotton-wool look. For such shots, use a slow shutter speed and use a tripod to prevent camera shake. For other shots, like sports events, you would probably want to keep a fast-moving subject sharp and defined, in which case you would use a fast shutter speed – unless of course you want to create the impression of speed.

Shutter Speed: 1/250 sec (f-stop: f/5.6)
Fast shutter speed: anything that moves is sharp

Shutter Speed: 0.3 sec (f-stop: f/32.0)
Slow shutter speed: everything that moves is blurred

USING AUTO-EXPOSURE AND OTHER AVAILABLE OPTIONS

To make it easier for the photographer to select an appropriate exposure setting while allowing the camera to handle the other parameters, some cameras offer several optional *shooting modes* in the creative zone. Each of these modes gives a different offering of settings you can choose from according to your priority and the camera model. The camera then makes all the other adjustments for you. 📖

NOTE: Tv NOT TV

In the table below, the abbreviation *Tv* is spelt with a lower case 'v'. This abbreviation is not to be confused with something related to a television set. *Tv* stands for *Time value* (i.e. shutter speed setting). Similarly, *Av* means *Aperture value* (aperture, f-stop setting) and has nothing to do with audio-visual, which is usually abbreviated as AV.

MODE	YOU set	CAMERA sets
P Program AE mode (basic) – lower to mid-range cameras that offer P Mode 📖 The aperture and the shutter speed are automatically paired and set by the camera. Unlike *Auto* mode, this mode gives you access to other settings that you can change if you wish, such as turning the flash off or on, setting the white balance, and more. You cannot, however, change the aperture or shutter speed (exposure settings) on the basic and many compact models.	You cannot change the aperture or shutter speed, but you can access other variables. 📖 For example, you can choose to adjust some of the following yourself (depending on your camera model): • Flash on/off • Slow-synchro • Snapshot mode • Infinity mode • Focus lock • Continuous shooting • Auto focus frame selection • White balance • ISO speed	• Shutter speed (Tv) *and* • Aperture (f-stop)
P Program AE mode (higher-end) – some higher-priced cameras 📖 Some higher-end cameras take *Program Mode* a step further and additionally allow you to select the most suitable pairing of shutter speed and aperture. 📖	As with P mode, but with the option to select a *pre-set pairing* of shutter speed and aperture	• Shutter speed (Tv) *and* • Aperture (f-stop) *but* offers you the option to select which pre-matched *combination* you prefer

MODE	YOU set	CAMERA sets
Av Aperture priority mode – on models where this is offered 📖 *Av* (Aperture value) or *f-stop* refers to the size of the aperture through which the light enters the camera. Some models offer the option for you to change the f-stop yourself, if this is your priority for a particular shot – e.g. to change depth of field. You set the aperture and then the camera adjusts the shutter speed accordingly. 📖	• Aperture (f-stop) only *plus* you can make changes to any of the other options that become available in *Av* mode on your particular model, which are not available in *Auto* mode 📖 Note: Lower f-stop = larger aperture: *used to reduce the depth of field* Higher f-stop = smaller aperture: used to increase depth of field	• Shutter speed (Tv), according to the aperture (f-stop) set by you
Tv Shutter priority mode – On models where this is offered 📖 *Tv* (Time value) refers to the time (how long) the shutter keeps the aperture open, also known as *shutter speed*. Some models offer you the option of changing the shutter speed for a particular shot – e.g. to capture moving subjects clearly, or blur a moving subject for effect. You set the shutter speed and the camera adjusts the aperture (f-stop) accordingly.	• Shutter speed (Tv) only *plus* you can make changes to any other options that become available in Tv mode on your particular model, which are not available in *Auto* mode. 📖 Note: Slower speed = blurred moving subject: used to create the impression of speed, or a misty, ethereal look Faster speed = sharper moving subject: used to retain clear definition	• Aperture (f-stop), according to the shutter speed set by you
M Manual mode – On models where this is offered. 📖 In this mode you *must* set both the aperture and also the shutter speed, according to your needs. This is for serious photographers who want to create specific effects by juggling with the shutter speed and the aperture *together* by reading the internal light meter. It is not recommended for the absolute beginner.	• Shutter speed (Tv) *as well as* • Aperture (f-stop) *plus* you can make changes to any of the other options that become available in *Manual* mode on your particular model, which are not available in *Auto* mode.	• Neither the shutter speed nor the aperture (you set both of them)

CHANGING THE CAMERA'S LIGHT SENSITIVITY (ISO RATING)

Light sensitivity settings on digital cameras are the equivalent of ISO ratings on film. Most digital cameras have settings with a sensitivity equivalent to ISO 100 and ISO 200 film. Many will have an ISO 400 setting. Raising the rating allows faster shutter speed and/or a smaller aperture, but if it is too high (above 400) this causes what's called a 'noisy image' (visible small coloured dots) which is especially noticeable on cameras with small sensors.

Very few cameras have settings lower than ISO 100, because 'noise' levels are so low at ISO 100 that there is no point in using a slower setting. Cameras with an auto ISO setting will automatically select an ISO setting from the range 100–200, or even 400, depending on the light level in the scene and the shooting mode being used.

One benefit of digital cameras is that you can change the ISO setting shot by shot, whereas with film cameras all the pictures taken on the same roll of film would have to be shot at the same film speed. 📖

EXERCISE: USING PROGRAM MODE (P) (where available)

1. With your camera set on **AUTO**, take a photo of any scene.
2. Next, check whether your camera has the **Program (P)** mode (possibly referred to as **Program AE**). 📖 If it is available, set your camera to this mode.
3. Access your camera's menu system 📖 to select one of the **Program (P)** mode options listed in the second column of the table on page 90 (opposite **P** mode), and change the setting you've selected.
4. Take another photo of the same scene.
5. Set the Mode Dial to **Review** (or **Replay**), and view each picture in turn to see the differences.
6. Repeat steps 3 to 5 with another option available in **Program** mode.
7. Repeat step 6 until you're familiar with the use of **Program** mode.

EXERCISE: USING APERTURE PRIORITY MODE (Av) (where available)

1. Check whether your camera has the **Aperture Priority (Av)** mode. 📖 If it's available, set your camera to this mode.
2. Change the **Av** setting to a lower value (lower f-stop), and the camera will increase the aperture and also increase the shutter speed accordingly. 📖
3. Take another photo of the same scene you shot in the first exercise.
4. Set the Mode Dial to **Review** (or **Replay**), and view each of the last two pictures in turn to see the differences, looking in particular for any difference in the focus of the background and foreground (depth of field).

EXERCISE: USING SHUTTER PRIORITY MODE (Tv) (where available)

1. Check whether your camera has the **Shutter priority (Tv)** mode. 📖 If it's available, set your camera to this mode.
2. Take a photo of a moving subject (e.g. traffic or people walking).
3. Change the **Tv** setting to a lower (slower) value, and the camera will decrease the aperture accordingly. 📖
4. Take another photo of the same moving scene.
5. Set the Mode Dial to **Review** (or **Replay**), and view each of these last two pictures to compare the differences, looking particularly for any difference in the focus (crisp or blurred) of the subject as well as the background and foreground.

No exercise is included here for *Manual* mode. We suggest that you become accustomed with the three creative modes covered in the exercises above, before experimenting with *Manual* exposure settings.

A few other settings to be aware of

USING FOCAL LENGTH TO DETERMINE THE BREADTH OF THE SCENE

On digital cameras, *focal length* simply means the distance between the lens and the image sensor, measured in millimetres. Stated simply, *focal length* determines how much of the scene a camera lens sees.

Viewfinder and LCD monitor:

When the camera is powered up what you see in the optical viewfinder and the LCD monitor would be what we can call the 'normal' scene view for your particular camera model. (See illustration below.)

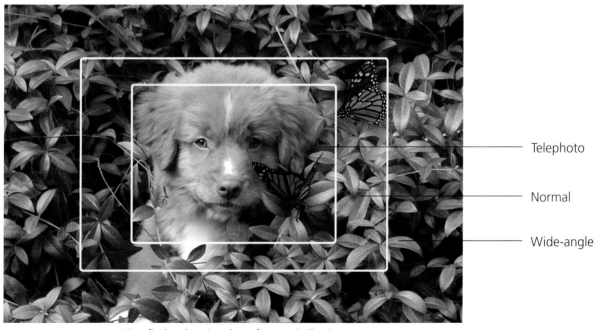

Telephoto

Normal

Wide-angle

Viewfinder showing three frames, indicating
what will appear in the picture for each focal length

Wide-angle – short focal length:
Widens the view so that there is more of the scene in view. The result is that everything appears to be further away and therefore smaller.

Telephoto – long focal length:
Brings the subject closer, making it look larger in the frame, thereby reducing the width of view so that you see less of what is on the sides of the subject.

 Zoom lens – This enables you to vary the focal length while retaining a high image quality throughout the zoom range. Zooming *in* on the subject (extending the lens outwards) increases the focal length to telephoto and brings the scene closer – also making it bigger, with less of the scene in view. Zooming *out* does the opposite: it shortens the focal length to create a wider angle so that the scene gets further away and more of the scene is in view in the frame.

TAKING EXTREME CLOSE-UPS WITH MACRO MODE
Digital cameras that have various scene modes usually have what is referred to as a *Macro* mode. When selected, the lens extends all the way out and adjusts the AF (auto-focus) sensors for close focussing. Macro capabilities vary by camera. Patience is required when shooting in macro mode as it takes a little longer for the camera to achieve focus. Macro mode is useful for taking close-up photos of small wildlife subjects such as insects and flowers. Using a tripod is recommended for Macro shots.

Normal

Macro

COMPOSING A GOOD PICTURE
As you saw in Chapter 3, some imperfect compositions can be fixed using editing software to crop, straighten and so on. But it's impossible to add back into a picture something you've chopped off through framing the scene badly.

 For example, in the photograph of the ship opposite, it is not possible to use editing software to position the ship in the gap between the trees if it has already sailed behind the branches when the shot is taken.

 It is important to take the time to compose your picture as best you can before pressing the shutter release button. The next page contains a few tips on what to avoid.

Avoid distracting backgrounds

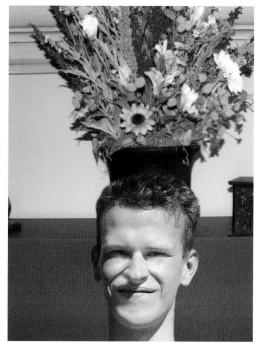

Spend some time composing your picture and examining its content. Observing how background objects are positioned is as important as the subject.

Avoid chopping content off

Make sure everything important is inside the frame. To get a shot where heads are not chopped off, step back to ensure your subject is framed correctly.

Prepare for the right moment

Anticipate how the scene will evolve and prepare your camera settings in readiness. Compose your picture carefully and when the time is right, take the shot.

Preview your picture in the LCD

If you have time, preview the picture you've just taken. If it is not how you want it, take another one … or two or three, until you have the shot you want.

 We strongly recommend that you keep your camera's manual with your camera and study it carefully, over and over, to make sure you understand the camera's many useful features and how to operate them. Digital cameras have a great deal to offer and it would be a waste to relegate a good camera to the ranks of a simple *Auto* mode point-and-click device when it is capable of giving you much more satisfaction and pleasure.

Getting photos off the camera

OVERVIEW
This chapter explains the various methods of downloading your digital photos from the camera:
* directly to a printer for printing, and
* onto a computer for editing, printing or sharing with others.

TIP: CONSERVING BATTERY POWER
If your camera came with an AC power adapter it's best to use it when downloading, in order to conserve the battery power for photography itself.

PRINTING DIRECTLY FROM A DIGITAL CAMERA
Some cameras allow you to select the images you wish to print and then use the camera's controls to send the selected images straight to a printer (usually a printer from the same manufacturer as the camera).

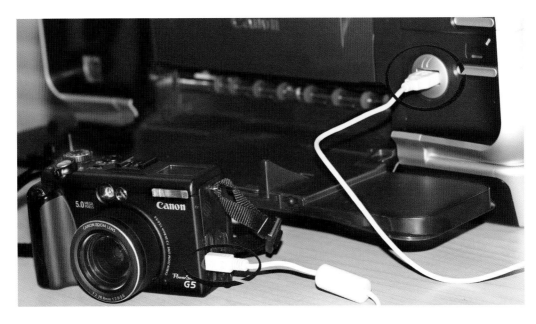

The printer needs to be able to accept a camera connection, or have a memory card slot or wireless connection. An alternative is to remove the storage card and take it to a photo lab to have the selected pictures printed, at a fee. Generally, most people download their pictures to a computer first as this method has several advantages:
* You can view all your images on the computer's monitor which is much larger than the camera's LCD monitor, thus making it far easier to see which pictures you want to print.
* It gives you the opportunity to edit the pictures first, which could include cropping and fixing lighting or colour problems, to get them to the state in which you'd like them printed.
We recommend downloading your images to a computer and then immediately erasing them from the memory card to free it up for more space for photo taking.

DOWNLOADING FROM CAMERA TO COMPUTER

There are several ways to download images from the camera to a computer. These depend on what type of camera you have, as well as the computer equipment available to you. The most common way is via a USB cable.

Using software to download the images

Once your camera has been connected to the computer you have two choices of software to use for the download: the software that was supplied bundled with your camera, or your favourite photo editing program if it supports downloading images. (The free software we've been using for this book, Picasa®, supports downloads from cameras, and works like a charm.)

Using the camera's software: Most digital cameras come with their own dedicated software (photo program) supplied on a CD with its own instruction manual.

1. With the computer switched on, insert the CD provided and follow the software manual's instructions and on-screen prompts to install the camera's software. 📖

Once the software has been installed you may need to shut down the computer so that the hardware (camera) can be connected safely. 📖

2. Connect the camera to the computer via its normal method of connection. 📖
3. If the computer was shut down, turn it on again and wait for it to boot up fully.
4. Open the photo software you have just installed and get familiar with how it functions. 📖
5. Follow the software instructions – the manual 📖 and the [F1] keyboard button for the Help menu – to set it up to save imported images to the folder **00Downloads To Sort** inside the **My Pictures** folder which you would have created in Chapter 2. (If it doesn't exist, we suggest you refer to p15 to create it before you start the download.)
6. When that has been set up, turn on the camera and the computer will detect the new hardware you have connected.
7. Follow the software instructions/prompts to start importing the images from the camera. (There is usually an **Import** button somewhere in the photo program's window that you'll need to click on.)
8. When done, turn off the camera and disconnect it from the computer.

TIP: REFORMAT THE MEMORY CARD TO CLEAR THE IMAGES

When you're sure all your images are safely on your computer, and you've disconnected the camera, turn the camera on again to reformat the memory card so that all the images are removed. 📖 Reformatting erases the images as well as existing data and directory structures on the card. This is similar to reformatting a computer's hard drive in order to start with a clean slate, and is recommended.
If you ever obtain a compatible memory card from someone else, or buy a new one, first format/reformat it before you start taking pictures with your camera.

Using other software (e.g. Picasa®): Good photo editing programs also give the option to pull new photos off the camera through an *Import button*. This is how it's done in Picasa®.

First you need to set Picasa® up so that it always downloads new photos to your *00Downloads To Sort* folder inside *My Pictures*. This needs to be done only once, then it is set up permanently, unless you decide to change it one day, which shouldn't be necessary.

1. If your computer system requires it, turn the computer off.
2. Connect the camera to the computer.
3. If the computer is turned off, turn it back on and wait for it to boot up fully.
4. Open Picasa®.
5. On the Picasa® Menu bar, click on **Tools**, then on **Options** to open the Options dialogue box.
6. If the **General** tab is not selected, click on it to select it and display its options.
7. Under **Save Imported Pictures In** near the bottom of the dialogue box click on the **Browse** button.
8. Browse to find the folder **My Pictures**, and double-click on the folder **00Downloads To Sort** (which you created in Chapter 2), to open/select it. (If it doesn't exist, refer to **p15** to create it now.)
9. In the **Browse to Folder** dialogue box that opens, click on **OK**.
10. Back in the **Options** dialogue box click on **Apply**, then on **OK**.

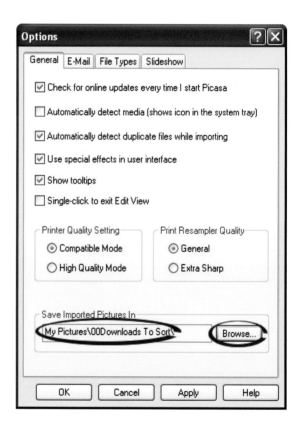

From now on, Picasa® will save all imported images to that folder for you to discard unwanted pictures and sort and move the rest to their final destination event folders.

11. Set the camera's Mode Dial to the correct setting for downloading (usually *Playback/Review*), and turn the camera on. 📖

12. Click on the **Import** button.

13. Click on **Select Device**.

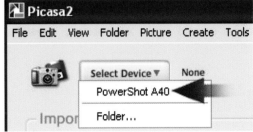

14. Click your camera model.

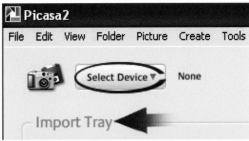

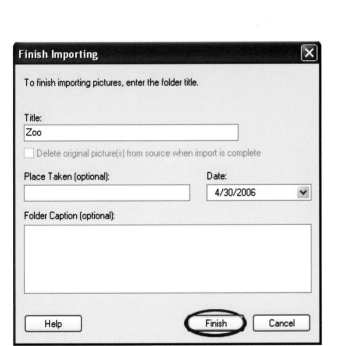

15. Wait while Picasa® downloads all the images on your camera's memory card and displays their thumbnails in the **Import Tray** on the left.
16. When no more images are being added, click on the **Finish** button on the bottom right of the Picasa® window and the **Finish Importing** dialogue box will open, inviting you to give that batch a name. (The download date will already be shown.)
17. In the **Title:** window you can type any description that will describe that batch of photos, or leave it blank.
18. If you wish, type additional information in the other windows.
19. When done, click on **Finish**.

Your newly downloaded images will now be saved to your hard drive in their batch folder within the folder *00Downloads To Sort*. If you named the folder for that batch, per step 17 above, the folder will have its own name in place of the download date, so you may want to include the date in the title.

 Never edit or 'tweak' your images directly on the camera's media card. This can damage the card and you could lose all the images. Rather first download all your images, disconnect the camera and do your editing in your favourite photo editing program.

DOWNLOADING FROM MEMORY CARD TO COMPUTER

To utilize a card reader or a PC card slot or adapter, simply remove the memory card from the camera and insert it into a little device that connects to your computer, either directly (a card reader) or via a PC card adapter.

Card reader: For a very small investment you can buy yourself a card reader, which is our personal choice of a safe method to transfer images quickly from camera to computer.

1. Plug card reader into the computer's USB port.
2. Insert the camera's memory card into the slot in the card reader.
3. On your Desktop, open **My Computer** (or Windows Explorer) and browse for the folder you've created and named **00Downloads to Sort**, in My Pictures.
4. **Double**-click on the **00Downloads to Sort** folder to open it.
5. **Double**-click on the new drive shown in My Computer (or Windows Explorer) and you'll see all the images on the memory card.
6. **Select all the images** in the usual way, then click and **drag** them into the **00Downloads to Sort** folder (or cut and paste if you prefer).

Plug-in card reader

TIP: PC CARD READERS
Some laptops have 5-in-1 card readers built into the computer. Simply slide the card into the slot and open your images from the designated drive.

Computer with built-in card reader

PC Card adapter: All new laptop computers now come with a built-in PC card slot. If you have this feature on your own laptop, it is an easy way to transfer your images from the camera to the laptop. You will need to purchase a PC card adapter to use with the card slot.

1. Insert the camera's memory card into the stand-alone card adapter, making sure the card is going in with the correct side up.
2. Insert the card adapter and the slide adapter into the laptop's PC card slot, so that the laptop can now access what is on the memory card.
3. Follow steps 2–6 as given in the previous item for using the card reader.

 Remember to make backup copies of your valuable photos as soon as possible. Refer to pp31–32 in Chapter 2.

Where to from here? 8

OVERVIEW

Once the digital photography bug has bitten you, you'll no doubt want to find out more about your growing interest, and possibly buy or upgrade your own digital camera. This chapter will give you some pointers to help you avoid the mistakes the uninitiated often make. It will also give you some ideas on where to find more useful information and keep up with developments in the world of digital photography.

Choosing a digital camera

The choice of digital camera depends a lot on what one's needs are. There are, however, several basic things that are important considerations when you're about to part with your cash and buy your first digital camera, or upgrade from your existing one.

LENS QUALITY – A MOST CRITICAL ASPECT

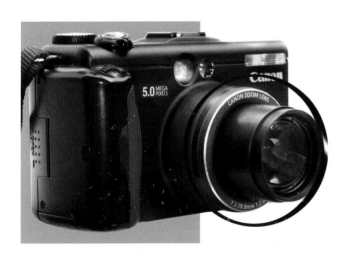

The most crucial aspect of any digital camera is the quality of its optics. Whatever the images will ultimately be used for (large prints, e-mailing to friends, displaying on a Web page, etc.) a sharp, clear, crisp photograph with good colour and contrast will always be desirable. This means that no matter what fancy components or features the camera has, if the lens is not good quality you will end up with less than satisfactory photographs.

The better-known cameras like Canon, Nikon, Olympus, Konica, Minolta, Pentax, Fujifilm, as well as some others, can usually be relied upon to produce quality photos. Be sure to ask about lens quality when considering a lesser known brand.

TIP: CHOOSING OTHER LENSES

A serious amateur who buys an expensive SLR (Single Lens Reflex) camera should definitely not try to cut costs by buying third-party lenses of cheaper brands. If you have a good camera, then use the manufacturer's recommended lenses.

PIXEL RESOLUTION

As already explained, the more pixels in an image – i.e. the higher the resolution – the better the quality and the larger the print size possible without pixilation occurring. (Pixilation means that the pixels can be seen with the human eye.) And the resolution story starts with the camera itself, because pixels are to do with *input* – what pixel resolution is used when the picture is first taken.

Cameras at the lower end of the price range can usually capture images of 640 x 480 pixels (*VGA resolution*) – i.e. about 1 million pixels, or one *mega-pixel*, to use the popular term. More expensive cameras have a much higher pixel capture capability than amateur digital cameras.

The mega-pixel resolution you require from a camera should be determined by what you'll be using your images for. *More* does not necessarily mean *best*. Best is what best suits your particular needs and your budget. Here are some general guidelines to help you.

Application	Mega-pixel size	Image resolution	Recommended print size (inches)	Minor pixelation may start	Serious pixelation may start (inches)
Web site, E-mail	1	640x480	Wallet	4x6	5x7 to 8x12
Web site, E-mail	1.2	768x1024	4x6	5x7, 6x8	8x12
Web site, E-mail	1.5	1024x1280	4x6, 5x7	8x12	
Web site, E-mail, Inkjet/Laser printer	2	1200x1600	4x6, 5x7, 6x8	8x12	
Inkjet/Laser print	2.5	1712x1368	4x6, 5x7, 6x8	8x12	
Inkjet/Laser print	3	1536x2048	4x6, 5x7, 6x8	8x12	
Inkjet/Laser print	4	1800x2400	4x6 to 8x12		
Inkjet/Laser print	6	2016x3040	4x6 to 8x12		

SPEED DOES COUNT

If you've ever used an earlier model digital camera you'll remember how slow they were at getting started. By the time your camera had booted up and was ready to take its first shot, that once-in-a-lifetime picture could long have passed. Then you had to wait again for the camera to ready itself before you could take your next shot. Today's cameras are much faster. Speed counts; seconds count.

You wanted this

But you got this

Camera speed depends on several factors such as:

Boot Speed	The time between turning the camera on to its being ready for the first shot.
Shutter Lag Time	The time between pressing the shutter release button to set in motion a chain of events that happen inside the camera before the picture is recorded.
Write Speed	The time it takes for the photo to be processed and written to the memory card before the next shot can be taken.
Burst Rate	Determines how many shots can be taken in quick succession (e.g. for sports events, animal or bird shots, etc.) before the camera must pause to save the captured data.
Memory Buffer	The RAM storage capacity, used as a memory buffer to store one picture's data temporarily, to free up the camera for the next shot.

It is advisable to know about these things and to ask the sales person or consult the camera's specifications to make sure you're choosing the camera you need for your particular purposes. Test the camera at the camera store, and see for yourself how fast it performs.

LCD MONITOR / OPTICAL VIEWFINDER

LCD monitor

Some entry level digital cameras do not have an LCD monitor, which we consider to be a distinct disadvantage. After all, one of the promoted benefits of going digital is that you can view your pictures on the camera to decide whether to discard some, or retake shots. Even though LCD monitors do have some limitations as mentioned earlier in this book, they are nevertheless a very useful feature to have on a digital camera.

Remember, the optical viewfinder shows about 80 per cent of the image that will actually reach the light sensor, while an LCD monitor is more accurate and 'sees' about 95 to 98 per cent of what will appear in the final photograph. So for accurate picture composing an LCD monitor is better than an optical viewfinder, when sunlight doesn't make it difficult to use (some manufacturers have already begun to address this problem).

If you'll be needing to take lots of photos where normal viewing through the optical viewfinder or LCD monitor are difficult – for example, around corners or over the tops of people's heads in a crowd – a swivel LCD monitor can be a very useful option that will allow you to see the screen even though the lens may be pointing elsewhere at the subject.

The camera at the back has a rotating LCD monitor, useful for framing a picture where the subject is not in your own line of vision. When not in use, these types of monitors are closed with the screen facing inwards to help protect it from scratches and damage.

Parallax correction lines on the optical viewfinder

As discussed in Chapter 5, for close-up shots it's important that there are parallax correction lines on the optical viewfinder to help you frame your picture without the problems of parallax error. When choosing a camera, remember to check that it has this feature.

Diopter adjustment for people who wear spectacles

Some cameras have a small dial or slider situated close to the optical viewfinder. Called a *diopter adjustment,* it controls the focus of the *viewfinder* (not the *lens*) and is used as an aid for people who normally wear spectacles. If you adjust this diopter to suit your eyes you'll get a clear image through the viewfinder, often without the need to wear your spectacles.

NOTE: THE DIOPTER IS ONLY FOR VIEWING
Adjusting the diopter has absolutely no effect on the actual focus of your photos.
It only gives you a clearer view of the scene.

WHAT SHOOTING AND SCENE MODES DO YOU NEED?

Virtually all digital cameras these days have a range of shooting modes and scene modes to choose from. Some cameras have some of the modes easily accessible on the mode dial, while others require access through the menu and scroll buttons. Higher end models have more modes on the dial to make it easier and quicker to change modes.

Mode selections range from fully automatic mode only, in the basic models, through Program (P) mode, Av (Aperture priority), Tv (Shutter speed priority) to Manual mode, stitch assist, and even the capability to shoot short video clips. Decide what level of photography you want to engage in and the modes you'll need, and buy accordingly.

STORAGE MEDIA

Another consideration when choosing a digital camera is what kind of storage media it uses. Before you make a final choice on what camera to buy, there are some questions to be asked:

- How much storage capacity (in megabytes) does the removable medium offer?
- Are extra units of that type readily available in your sphere of travel, if you should need an extra or replacement one? In what capacities do they come?
- Will you be transferring your images directly to a device via a slot or adapter? If so, what type of cards can it accommodate?

Popular image storing cards available

Although there are several different cards available, each digital camera model normally takes only one type of card. Once you've chosen the camera, there's not much you can do about what *type* of memory card it takes. What you *can* do, however, is make sure that the type of card used by that camera is available with a good sized memory according to your needs. Higher-pixel cameras should have a higher memory card capacity. The table below shows approximately how many images can be stored on each card size according to the camera's pixel capture capability.

Number of images per memory card						
Card capacity	**32MB**	**64MB**	**128MB**	**256MB**	**512MB**	**1GB**
3 megapixel camera	25	51	105	212	424	852
4 megapixel camera	16	32	64	128	256	512
5 megapixel camera	11	25	50	101	203	407
6 megapixel camera	10	20	40	80	160	320

> **TIP: BEWARE THE CAMERA'S QUOTED IMAGE CAPACITY!**
> Where a *camera* is stated to be able to store a certain number of images in its internal memory,
> be aware that this number is often based on small images of low resolution (to make the camera
> sound impressive). The best measure is megabytes and gigabytes, not the number of images.

OTHER CONSIDERATIONS

Battery power and costs: What type of batteries does the camera take? Don't just look at initial cost; consider
the longer-term running costs:
- How many hours of shooting do the batteries offer?
- Are they rechargeable?
- Does the camera price include a battery charger and AC adapter, or are these options at an extra cost?

Tripod mount: Does the camera have a threaded socket underneath for screwing in a tripod to keep the camera
steady when shooting night shots or using a slow shutter speed? Will you need to use a tripod for the kind of
photos you intend taking?

Durability: Open the battery compartment and the flap that takes the USB cable to check whether the fitting is
flimsy or durable.

Connectivity: How does the camera connect to the computer? Does this meet the needs of your equipment.

User-friendliness: Try the camera out to see whether it is easy to operate for your hand size, whether you're
left-handed or right-handed. Are the buttons in the right places for your kind of grip? Are menus and modes easy
to access quickly?

Bundled software: Does the camera come with its own photo editing software, and if so, what can it do? Do
some Internet research on the software that is offered with the camera you're interested in buying.

CATEGORIES OF DIGITAL CAMERAS

Digital cameras come in a range of features with prices to match (more or less). Decide not only what you'll be
using the camera for, but also what you're prepared to pay. Visit camera stores and surf the Internet to get a good
feel of what's available. Here is an overview of the kinds of cameras available at the time of writing, to give you an
initial idea. Visit the book's companion Web site for links to sites offering reviews of digital cameras and user
discussion forums.

Mobile (cell) phone cameras: for taking impromptu fun pictures or useful instant shots (such as at the scene of
a car accident). These cameras are not suitable for serious photography as they usually have a low resolution,
making for poor image quality.

Entry level compact cameras: offer basic functions for the absolute beginner who simply wants to aim and
point to take photos for making small prints, e-mailing to others or putting up on Web pages.

Deluxe point-and-shoot: higher mega-pixel cameras for those who have more than a basic interest, but still
want the camera to make most of the settings automatically, yet with enough options to allow for some manual
experimentation later.

Prosumer: cameras that offer more personal control over shutter speed and aperture, for serious amateurs who
are interested in taking digital photography quite a few notches further.

Digital SLR: single lens reflex cameras for serious, advanced amateurs and professional digital photographers
who need a camera that compares with the traditional 35mm film cameras.

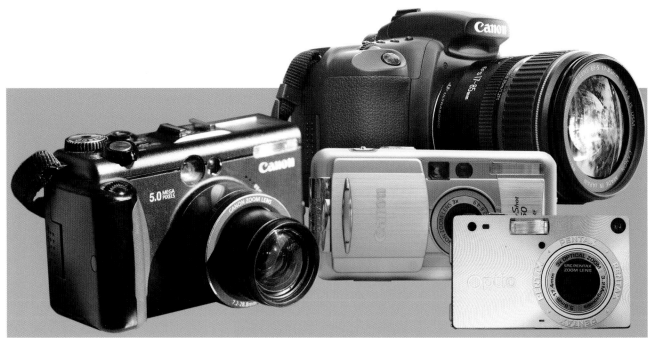

Top right: high-end Single-Lens Reflex (SLR)
Front row left to right: (higher end) Prosumer; Deluxe point-and-shoot; Entry-level (credit-card size)

BUYING TIP: BUY ACCORDING TO YOUR NEEDS

It's easy to get excited, especially when presented with the wide range of beautiful equipment at the camera store. Don't allow yourself to be talked into an expensive, high-end camera by an over-zealous sales person who's on commission, if that's not the kind of camera you really *need*. If all you need is a camera with an LCD monitor that will do all the settings for you, then that's what you should buy. There is no point in spending good money for all the bells and whistles if you're not going to use them. Rather put that money towards a high-capacity memory card that will enable you to snap away to your heart's content without any memory concerns; and a spare set of rechargeable batteries so you'll never run out of power.

CHECKING YOUR BRAND NEW PURCHASE

When you buy a digital camera make sure the package contains all the bits and pieces specified on the box. To avoid any possible hassles with the supplier, ask the sales person to check the contents with you before you take your new purchase home. If you buy by mail order, check everything thoroughly before you start using your camera, and contact the supplier immediately if there is any problem with your new purchase.

As a minimum, you should receive the following items besides the camera itself:
- a set of batteries, because all cameras need to have power
- a media storage card that stores your photos inside the camera
- a removable lens cap if your camera doesn't have an automatic lens protection mechanism
- a cable for connecting the camera to a computer
- photo editing software on a CD
- the instruction manual for the camera, with a separate one for the software
- a case to keep your camera in when not in use, and a safety strap (usually the wrist type).

CAMERA CARE

There's one aspect many camera users ignore and that's the practice of keeping their camera lens clean. You aren't going to have sharp photographs if your lens has a greasy smudge or dry raindrops on it. We do not recommend exhaling onto a lens and wiping the fog off with a scratchy sleeve or shirt tail, or even a clean handkerchief. Also, don't use tissue paper; the fibres can scratch the lens.

For a small price with a big return buy yourself some lens cleaning fluid and a lens cleaning cloth from a camera store. A special blower brush is also invaluable for removing dust from hard-to-reach places on SLR cameras with image sensors.

Always use proper lens cleaning equipment

COMPUTER REQUIREMENTS

What type of computer you'll need will depend on how serious you intend to become with digital photography and how many digital photographs you'll be creating in the next few years. The general rule of thumb regarding computer processing capacity applies just as much when it comes to working with digital photography as it does with computer games and other computer applications: buy the biggest and fastest computer you can afford.

Processing speed: measured in gigahertz (GHz) is important for processing large images.

RAM (Random Access Memory): is also important, and is a cost-effective way of boosting computer performance. As a guideline:

- 512 megabytes (MB, or megs) of RAM: basic photo work
- 1 gigabyte to 2 (GB) of RAM: extremely large photo work (RAW file formats, composites, layering, panorama work) – for the very serious photographer

Hard drive size: important not only for image storage but also for providing virtual memory when sophisticated photo editing programs (such as Adobe Photoshop) are being used.

A good-sized monitor: (17-inch or bigger) of good quality is essential for the serious photographer, because this is where you view your images and do your edits.

- LCD monitors (as used by laptops) should be operated at their native resolutions
- Set the colour depth to the highest available setting (32 bit or 'true colour')
- Use the monitor's controls to set colour balance at 6500° K. (Less expensive monitors may not have this function.)

Finding out more

Digital photography is evolving all the time, so we suggest that you supplement your reading by visiting several digital photography Web sites for reviews by professional photographers as well as comments from users. These are posted in the various forums on the Web. Addresses for some of these sites are provided on this book's companion Web site (see below). If you're not a regular Internet user, then take advantage of the many digital photography magazines that are available at bookstores.

Visit our Web site for links

To find Internet links to current Web sites offering reviews of various digital cameras visit this book's companion Web site at **http://www.reallyeasycomputerbooks.com**

Our Web site also includes a useful buyer's downloadable checklist to help you identify your own photography preferences so that you can more easily determine what kind of camera will best suit your needs.

Enjoy the fun and creative world of digital photography!

Our thanks

**We'd like to thank the following for their contribution
in helping us produce this book:**

**Contributors of some of the photographs:
Angie, Cassie, Heidi, Karin and Rebecca**

**A special thank you to our little stars:
Clara, Hannah, Isabella, Leia, Liam and Samuel**

**And to our furry friends:
Estella, Jesse and Kirby**

Technical assistance: Lori and Quinton

INDEX

First published in 2006 by
New Holland Publishers Ltd
London • Cape Town • Sydney • Auckland
www.newhollandpublishers.com

86 Edgware Road
London W2 2EA
United Kingdom

80 McKenzie Street
Cape Town 8001
South Africa

14 Aquatic Drive
Frenchs Forest, NSW 2086
Australia

218 Lake Road
Northcote, Auckland
New Zealand

ISBN 978 1 84537 245 3

Publishing Managers: Simon Pooley and Claudia dos Santos
Commissioning Editor: Alfred LeMaitre
Editor: Gill Gordon
Design: Hirt & Carter Studio
Production: Myrna Collins
Proofreader and Indexer: Anna Tanneberger
Consultant: Duncan Soar

Reproduction by Hirt & Carter (Pty) Ltd
Printed and bound in Singapore by Tien Wah Press (Pte) Ltd